AMERICAN PRISONER OF WAR CAMPS
IN ARIZONA AND NEVADA

KATHY KIRKPATRICK

For Rhonda and Luccia

America Through Time is an imprint of Fonthill Media LLC
www.through-time.com
office@through-time.com

Published by Arcadia Publishing by arrangement with Fonthill Media LLC
For all general information, please contact Arcadia Publishing:

Telephone: 843-853-2070
Fax: 843-853-0044
E-mail: sales@arcadiapublishing.com
For customer service and orders:
Toll-Free 1-888-313-2665

www.arcadiapublishing.com

First published 2018

Copyright © Kathy Kirkpatrick 2018

ISBN 978-1-63499-053-0

All rights reserved. No part of this publication may be reproduced, stored in a retrieval system or transmitted in any form or by any means, electronic, mechanical, photocopying, recording or otherwise, without prior permission in writing from Fonthill Media LLC

Typeset in Mrs Eaves XL Serif Narrow
Printed and bound by CPI Group (UK) Ltd, Croydon CR0 4YY

Contents

List of Illustrations	4
Introduction	5
Background	8
Preparing for War	12
Global Situation	14
Planning and Building the Camps	18
Managing the Camps	20
Life in the Camps	25
Italian Service Units	42
Death in the Camps	46
Returning Home (1945-46)	48
After the War	51
POW Camps by Location	55
Death Index	66
Burial Locations List	68
Appendix A: POW Labor	69
Appendix B: Museums and Websites	80
Bibliography	82
Acknowledgments	90
Index	91

List of Illustrations

Speak American poster 5	outdoor concert at Utah ASF Depot 34
Vatican Secret Archives entrance 7	Artifacts at Florence, AZ museum 35
POW camps, hospitals, cemeteries map 7	ISU Chapel at Utah ASF Depot 35
German POWs at Fort Douglas in 1917 10	POW labor contracts ... 37-40
Overview of Fort Douglas .. 10	church art in Umbarger, TX 41
WWI POW monument in Fort Douglas Cemetery ... 11	ISU Troop Review at Utah ASF Depot 43
Service Command Areas in USA in 1942 11	Italian Service Unit club ... 45
Train photos at Utah ASF Ogden 13	wedding announcement from Camp Atterbury 45
Bryon Hot Springs ... 15	Fort Douglas cemetery headstones 47
POW ID Card, Turrini ... 16	ISU Good-Bye note from Utah ASF Depot 49
POW assignment card, Turrini 17	Wilson Longo, former POW 50
POW camp Gardens ... 19	POW Reunion at Hereford, TX 52
POW barracks ... 19	Former POW TV Interview in Ogden, UT 53
Guards with dogs at Ogden, UT 21	Mary Ravarino, former farmer hosting
Guard Thomas M Todaro ... 21	POW workers ... 54
Orazio and Angelo Vecchio 22	POW camps in AZ ... 55
Official POW Postcard … ... 22	CAMA map ... 59
POW groups with D'Onofrio and Selmi 24	Marana, AZ tent Camp ... 59
pow camp American girls and pow camp nurses ... 26	Florence, AZ Camp views ... 60
German typing class and POW_Camp_Art_Work ... 28	Papago Park, AZ … .. 61
Italian POW cooks at Utah ASF Ogden 29	Former POW stories ... 62-63
Italian bakers at Utah ASF Ogden 30	POW camps in NV ... 65
Pin-ups at Atterbury and soccer team at Utah ASF 31	Cal-Nev-Ari ... 65
Postcards .. 32	Ft Bliss National Cemetery 68
decorated mess hall and party at Utah ASF Depot 33	Funeral at Camp Monticello, AR 68
ISU band at Utah ASF Depot 34	POW labor ... 69-79

Introduction

America is a nation of immigrants, so hosting prisoners of war (POWs) from their homelands brought mixed feelings among the civilians and military in the communities where the prisoners were housed and worked. For many farmers that had immigrated to the Midwest, being able to contract for German POW labor not only eased the labor shortage, but it also brought the opportunity to speak their native language, perhaps to learn about family and friends left behind when they immigrated to America. It also often gave them the opportunity to provide additional food for men who worked hard for them and shared their friendship. Although these Americans had sons fighting in the war, they were more aware of the lack of choices these German prisoners had in their own lives than those who had not left an oppressive homeland.

The same situation applied to Italian immigrants and Italian POWs with the additional benefits of a less strained relationship after Italy became a part of the Allied cause in September 1943. The resulting friendships (and some marriages) show the very positive results of their experiences under very difficult circumstances.

In fact, when German-American or Italian-American families were given permission to hire prisoners of war to work on their farms or canneries, they were being given a measure of approval often missing in their own communities. In 1940, 330,000 Germans and 694,000 Italians had registered as aliens. Those not living on the coasts were not displaced, but suffered the name-calling and ostracism promoted by the government and media directed at those groups

From "una Storia Segreta" by Lawrence Distasi. The licensing metadata from the picture claims that it is a "work prepared by an officer or employee of the United States Government as part of that person's official duties."

of people during that time to promote the war effort. They could be arrested just for translating English into German for an aged grandparent.

The stories shared in the course of researching this topic include a moving description by a young Girl Scout raising the flag near Park City, UT while a truck load of prisoners passes by, with tears in their eyes. Even as a child, she understood that those men deeply loved and missed their children now living in harm's way.

Following the war, some of these farm families corresponded with the former prisoners until their deaths. A treasure trove of about 350 letters and photos from German former prisoners has recently been discovered in a home in Tennessee. They are now housed at the Lipscomb University in Nashville. They met by working on that farm and kept in touch over the years. But it was secret. The letters were found in a cereal box in a closet and even the children of this woman did not know about them.

For many years into the 1970s and 1980s, as late as 2009, there were reunions and family trips made by former prisoners to their old camps and the farms where they worked. They also visited the graves of their comrades who did not survive to go home at the end of the war.

Of the half-million German immigrants arriving here in the United States from 1947-1960, several thousand had spent time here as prisoners of war. The same can be said of Italian immigrants after World War II. They had friends and good experiences here that motivated them to move here themselves.

Even among those enemy aliens who were forced to repatriate at the end of World War II in exchange for Americans and for other reasons, the vast majority had agreed to the arrangement because it guaranteed them the ability to return to the US at a later date. They later used that agreement to return home to the US. That included Germans, Italians, and Japanese.

Prisoners were moved between Service Command areas in 1943 as the US built more camps and received more prisoners from overseas. Later, the prisoners were moved within a Service Command as necessary to provide seasonal labor on farms and in canneries as well as other work necessary for civilians as well as the military population.

Using a variety of sources in the United States and Italy, the complete story will be told. Sources cited include military records now housed at the National Archives II (in College Park, MD), documents from the Italian Army Archives in Rome (aka Stato Maggiore Esercito), L'Ufficio Informazione Vaticano per prigionieri di guerra istituito da Pio XII in the Vatican Secret Archives, as well as many books, articles, websites, and photographs.

Also utilized are interviews with former POWs, guards, translators (and their families) and many other sources both published and unpublished. Their experiences will also be compared to those of German POWs and internees held in America during World War I.

Introduction

Entrance to the Vatican Secret Archives, photo by author.

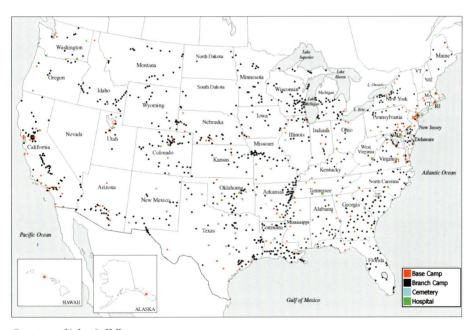

Courtesy of John Saffell.

Background

By the time the US entered World War II (WWII), almost the whole world was at war. This situation included large numbers of POWs which could no longer be supported by the limited resources of the British and French who captured many of them, primarily in North Africa in 1939.

The US had already prepared plans for camps to house large numbers of enemy aliens, so assisting with prisoners captured by the British was easily incorporated into those general plans. It was determined early that the US would not be imprisoning as many enemy aliens as first planned. The number of resident aliens who matched the original enemy alien profile was much larger than anticipated, so implementing that original plan was not possible.

During World War I (WWI), there were only 1,346 POWs held on United States soil. They were the crews of German military ships lying in US ports when the war began. They were held in the same five locations as civilian enemy aliens, plus four additional locations for a total of 5,887 prisoners of war. All other prisoners of that war captured by the US were held in France.

Those US locations included the following:

War Prison Barracks #1 - Fort McPherson, East Point, GA - 100 prisoners maximum
War Prison Barracks #2 - Fort Oglethorpe, Catloosa County, GA - 800 prisoners maximum
War Prison Barracks #3 - Fort Douglas, Salt Lake City, UT – 406 POWs and 786 enemy aliens.

On 21 March 1918, the POWs were transferred from Fort Douglas to Fort McPherson. On 19 Jul 1919, 108 Conscientious Objectors arrived at Fort Douglas from Fort Leavenworth, KS. They were housed in the compound left vacant by the POWs.

Branch camps under the camps in GA:

Camp Devens, Ayer, MA - 100 prisoners maximum
Camp Grant, Rockford, IL - 100 prisoners maximum
Camp Jackson, Columbia, SC - 100 prisoners maximum
Camp Sevier, Greenville, SC - 100 prisoners maximum
Camp Sherman, near Chillicothe, OH - 100 prisoners maximum
Camp Wadsworth, Spartanburg, SC - 100 prisoners maximum

These camps were run by the Provost Marshal General's Office (PMGO) of the US Army. Initially, there were no distinctions between captured German sailors and enemy aliens rounded up from across the US. However, it soon became apparent that the two groups were quite different, and efforts were made to put different groups into different camps.

Another camp, called an Internment Camp, was established at Hot Springs, NC, and run by the Immigration and Naturalization Service (INS). It held 2200 Germans from commercial ships in US ports when war broke out in 1914. They were placed at Hot Springs in May 1917 for the remainder of the war. Burials from this location were removed to Chattanooga National Cemetery.

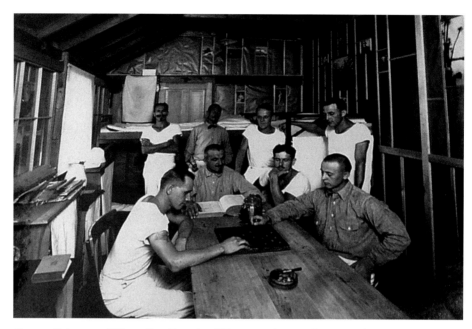

German Prisoners of War at Fort Douglas, UT in 1917 (crews of German ships) and view of the Camp. Used with permission, Utah Historical Society.

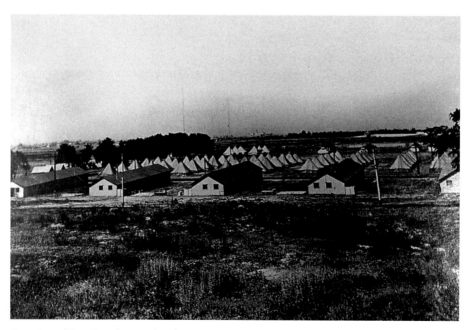

Overview of Fort Douglas. Used with permission, Utah Historical Society.

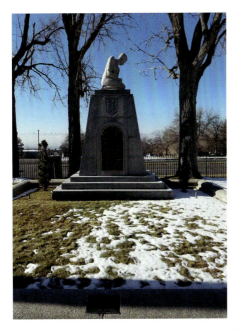 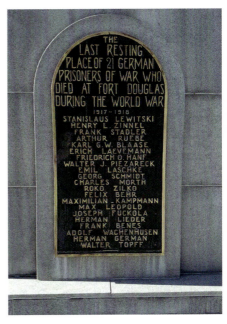

Monument to German POWs from WWI. We didn't separate the enemy aliens from the POWs, so only two of the twenty-one men on this list were POWs. Photo by author.

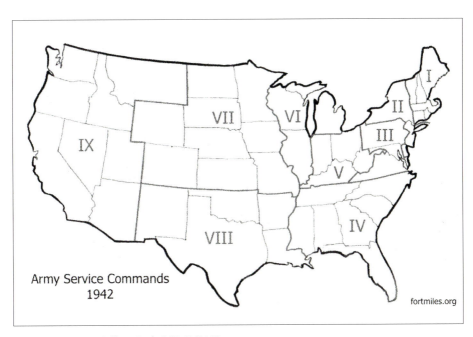

From NARA II in College Park, MD, RG 389.

Preparing for War

The military headquarters/training for the 9th Service command moved inland from the Presidio of San Francisco, CA to Fort Douglas, UT at the end of 1941 to make it less vulnerable to a Japanese attack.

The US needed:

1. Labor, since most able-bodied young men were expected in military service and efforts to recruit women into the workforce had only limited success. However, Rosie the Riveter became iconic and female pilots as well as clerks (military and civilian), nurses, teachers, and many other occupations gained workers from this effort. Those numbers decreased immediately after the war when the men returned home, but steadily increased as time passed.

2. Supplies for military troops overseas as well as both military and civilians at home including timber, cotton, tobacco, food (planting, harvesting, canning, fishing), clothing, arms and ammunition and transportation vehicles for land, sea and air.

3. Building and maintenance of new and expanded military installations as well as roads, railways, airfields, dams, and camps for POWs and enemy aliens.

Train at Utah ASF Depot, courtesy of Special Collections Department, Stewart Library, Weber State University.

Global Situation

POWs held by the British and French were straining their limited supplies, so they needed to be farmed out to other Allied nations (Algeria, Australia, Canada, Egypt, Great Britain, India, Kenya, Libya, the Middle East, South Africa, and the US).

POWs were being held in the various theaters of war, but the numbers were much greater than could be used for supply and support behind combat lines. Great Britain held 23,000 German and 250,000 Italian prisoners in August 1942. Plans were made to transport them to places where their care would not pull men from combat and where their labor could be used to ease shortages caused by men away from home.

Generally, ships carrying supplies and men into the European and Mediterranean theaters of war were used to transport POWs back to America, Canada, Australia, etc. While many POWs worried about getting bombed or torpedoed by their own nations, there were few incidents. The SS Benjamin Contee was torpedoed off the coast of Algeria on 16 August 1943 by German aircraft. The ship proceeded to Bone, to Algiers and then to Gibraltar, where emergency repairs were made, then to New York City, arriving 29 January 1944. The bodies of thirty-six unidentifiable Italian prisoners (900 British-held Italian prisoners had been on this ship before the attack) were removed from the most damaged part of the vessel and buried at Long Island National Cemetery.

The German POW population in the US in May 1942 was only thirty-one with one Japanese POW. There were no Italian POWs in the US at that time.

The Italian POWs were captured by British, French and American troops between 1939 and 1943 in North Africa and Europe. They first arrived in the US in early 1943 through the New York Port of Embarkation.

For the captured officers and naval crews, interrogation centers were their first stops in America. Fort Hunt, VA was the first of these centers. These interrogators denied torture accusations and criticized the Bush administration when they were honored near Alexandria as part of the US Army's Freedom Team salute program in 2007. The National Park Service (NPS), particularly the George Washington Memorial Parkway which now contains the former Fort Hunt, is interviewing veterans of P.O. Box 1142 (as it was known then) to tell their story. The former interrogators include John Gunther Dean, later a career

Courtesy of Byron Hot Springs.

Foreign Service Officer and ambassador to Denmark who said, "We did it with a certain amount of respect and justice". George Frenkel said, "During the many interrogations, I never laid hands on anyone." He said, "We extracted information in a battle of the wits, I'm proud to say I never compromised my humanity."

The other known interrogation center was Byron Hot Springs, CA, also known as P.O. Box 651. Following the example of the British to gain maximum cooperation with excellent living conditions, this center was used primarily for the highest-ranking officers while Fort Hunt was used primarily for naval crews. Information gained at Fort Hunt was also used later in the murder trials of naval POWs accused of murder in the camps.

A third location appearing in the camp lists as restricted listing, the same designation as the two locations above, might be Pigeon Forge, TN, although documentation has not been located to confirm this location.

These three centers were run by a combination of Military Intelligence, an agency of the Adjutant General's Office (G-2) and the Office of Naval Intelligence (ONI), so are listed on PMGO lists of POW camps as restricted listing camps.

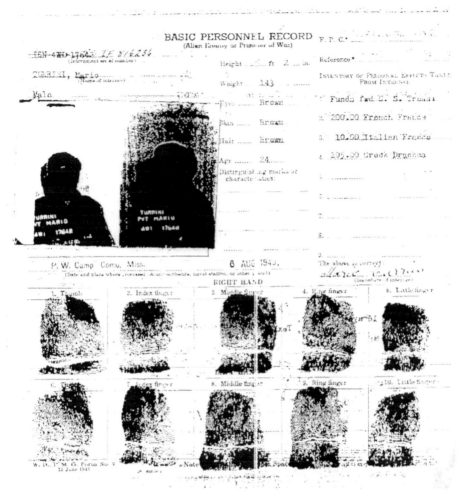

This ID card for Mario Turrini was created at Camp Como, MS. Note that the ID# was crossed out when they realized he already had a POW number assigned by the British who had originally captured him. In the far-right column you can see that he had coins from France from his service in Tunisia, plus coins from Italy from his Italian Army pay, plus coins from Greece, his last duty station before Tunisia. These documents are courtesy of his son, Marcello, who lives in Italy.

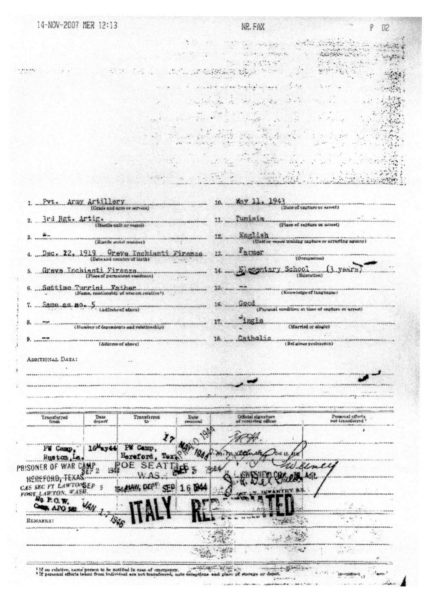

This card for Mario Turrini was created at Camp Ruston, LA, his location after processing at Camp Como. It shows that in May 1944 he was transferred to Camp Hereford, TX. This is part of the sorting process and he was categorized as not cooperative since he didn't sign up to be a co-belligerent in the Italian Service Units (ISU) after the fall of Mussolini. In September 1944, he was transferred to the Seattle Port of Entry, particularly Fort Lawton from which he sailed two weeks later for duty at POW Camp APO 950, AKA Fort Armstrong, Honolulu, HI. The Italian prisoners weren't sure where they were going and there was unrest among the African American units at Fort Lawton, so when one of the Italians committed suicide, three African American soldiers were convicted of murder. They weren't cleared until 2005, primarily because of the research for the book, On American Soil by Jack Hamman.

Planning and Building the Camps

Initially, enemy alien camps were planned for 100,000 internees. However, even after it was determined that original parameters for designating enemy aliens as potential threats were too broad and could not be implemented because of the vast numbers of people involved, the camps under construction were re-purposed as POW camps. They expected to fill them with POWs already captured by the British, about 100,000.

Lessons learned in WWI led to the separation of POWs (run by the PMGO of the Army) and enemy aliens (run by INS within the Department of Justice (DOJ)). Also in the wake of WWI were the agreements made at the Geneva Convention in 1929. It was determined that the US would (usually) follow such agreements not only because of the legal obligations, but also in hopes of reciprocal treatment by our enemies.

Among those soldiers captured in German uniform were men who considered themselves another nationality, such as Austrian, Czech, Swiss, Italian, Russian, Mongol, Hungarian, Romanian, and more. Among those captured in Japanese uniform were Koreans. Among those captured in Italian uniforms were Slavs (present day Croatia, Bosnia and Slovenia), Albanians, and Ethiopians. It was quickly learned that these groups needed to be separated in the POW camps both at home and abroad. In many of these groups were those who claimed US citizenship.

One of the POW camps had previously been used as a WWI POW camp, Fort Douglas, UT. Some were already military installations, like Fort Jay, NY. Some were former Civilian Conservation Corps (CCC) camps, like Fort Hunt, VA. Many were new purchases, like Camp Monticello, AR.

There were several potential standard plans, adapted to different climates and geographical considerations, but ultimately, each camp was unique in its layout due to geography and transportation infrastructure. In addition to building barracks, mess halls, warehouses, administrative buildings, and a hospital, the first commanding officer of the Utah ASF Depot POW camp, UT designated fifty acres nearby to grow crops to help feed the POWs. The crop yield was so bountiful it was shared with the Depot cafeteria, the Depot quartermaster, Bushnell General Hospital (in Brigham City), and the Ogden Air Service Command at nearby Hill Field. A similar assortment of buildings and garden area was described at other locations.

Planning and Building the Camps 19

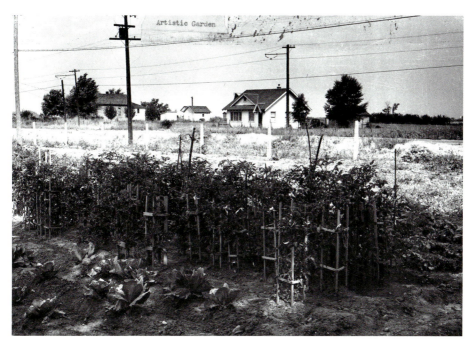

Garden at Utah ASF Ogden, courtesy of Special Collections Department, Stewart Library, Weber State University.

Display at Arizona Historical Society Museum in Phoenix, AZ.

Managing the Camps

Security was a primary concern. Guards were a combination of military (often older men and wounded combat veterans) and civilian. Sometimes long-lasting friendships developed between the guards and the POWs they watched, particularly among the interpreters.

In a successful effort to conserve manpower, it was the experience at Utah ASF Depot that one woman with a dog could patrol the same area as two men.

The POW work details were supervised by guards armed with carbines and rifles. Originally, the ratio was one guard to ten POWs, but over time diminished to one guard to thirty-two prisoners. When US Army personnel were not available, the commander could acquire guards from other sources. Handcuffing or abuse was forbidden. Each of the guard towers in the compound was occupied by a guard equipped with machine guns.

Sometimes the US Army translators were also guards, like Thomas M. Todaro, who worked at Camp Monticello and later at Fort Leonard Wood, MO. Translators (usually US Military) were assigned to camps. However, US Military translators for Italian Service Units (ISU) were assigned to the units which moved from camp to camp as needed to provide services.

The POWs were soon discovered to be an uneasy, even dangerous, mix of several nationalities, languages, and ideologies, regardless of their uniform. They were then segregated by nationality, politics and rank. In many camps, the officers were simply held in a separate compound from the enlisted, as directed by the Geneva Convention. However, compounds at camps Beale, Blanding, McCain and Papago Park were designated for German naval crews. Camp Alva was for Nazis. Camps Blanding, Campbell and Camp Devens, were anti-Nazi camps. Camps Hereford, Monticello, and Weingarten were for Italian Fascists. These divisions into Nazi and anti-Nazi were based on judgments made by G-2, the army intelligence unit.

Some of the captured men gave information to the US. In return, they were promised to be placed in other camps than the men with whom they had worked and been captured since those men knew of their treason to them. Unfortunately, the US did not always keep their promise. The best-known example is that of the murder of Werner Max Herschel Drechsler at Papago Park. This was the site where Nazis murdered a man who was known

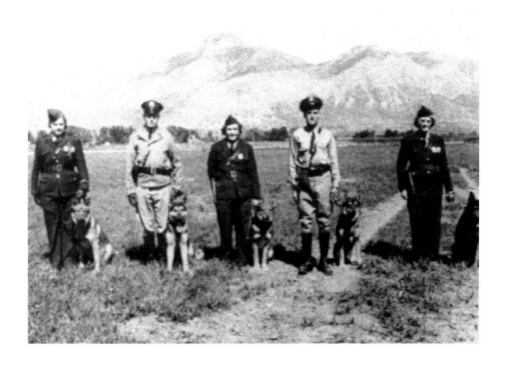

Above: Utah ASF Depot guard photos, courtesy of Special Collections Department, Stewart Library, Weber State University

Right: Thomas M. Todaro, who worked at Camp Monticello and later at Fort Leonard Wood, courtesy of his son

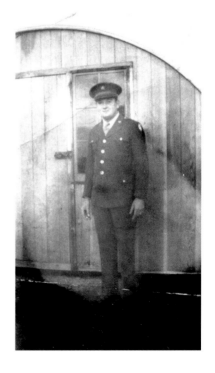

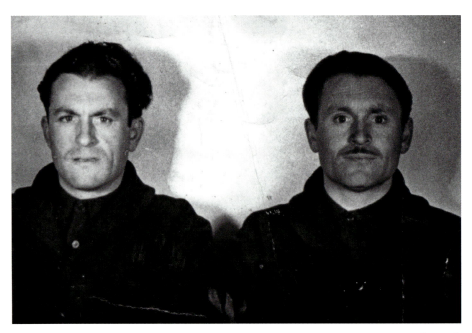

Orazio and Angelo Vecchio, brothers and Italian Prisoners at ASF Depot Ogden Courtesy of Orazio's grandson, Orazio Vecchio, living in Italy.

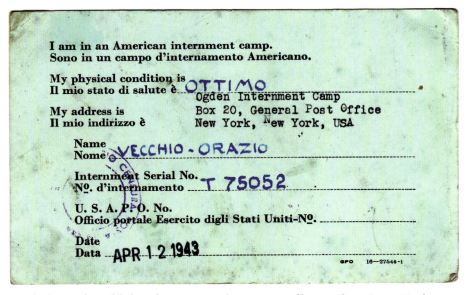

Standard POW form, filled out for Orazio Vecchio, courtesy of his grandson, Orazio Vecchio.

to have revealed military secrets to the Allies. He had been promised never to be placed in a camp with submariners, but when it happened he was killed within hours. The men who killed him, although they were following the same directives followed by all captured military, were sentenced to death and hanged at Fort Leavenworth after the end of the war. This was not America's proudest moment.

The generalities do not take into account transfers from camp to camp that were frequent and based on additional factors, such as work, health, and relationships. Most POWs did not fall into the above categories, they were young men who grew up in societies with mandatory youth groups and mandatory military service.

After initial interrogation, the German Generals were placed at Camps Clinton and Dermott while Italian generals and officers were at Camp Monticello. Additional German officers were held at Crossville.

G-2 interviewed these officers; however, the highest-ranking officer in these interrogation teams was a major, and therefore not qualified to deal with an officer of higher rank. Consequently, cursory and sometimes erroneous conclusions were drawn, heavily influenced by other high-ranking officers who were invited to participate.

A glaring example of this was the input of Italian General Trezzani who used the opportunity to cast doubt, and worse, calling another general a Nazi. He used this ploy on officers of similar rank to promote himself with the Americans. He used it to great advantage to become the head of the Italian Service Units (ISU) in the US and later in charge of rebuilding the Italian Army in post-war Italy.

Additionally, Italian Royalists and career army were considered Fascist while German career army were considered Nazi, simply for participating in required youth groups or in support of Franco (military service) in Spain. There was so much more to the story.

Public opinion was most loudly expressed by those with the greatest fear of enemy camps in their towns, or by those who hoped to profit from the use of POW labor in their businesses. Most Americans viewed the new camps with caution, but acceptance, and gradually came to appreciate the additional civilian jobs and affordable labor source. Some even developed friendships which lasted long after the war ended.

Each prisoner was processed either when captured or when they arrived in the US. This process included searching, delousing, disinfecting, fumigation, bathing, registration, clothing issue, quartering and medical inspection.

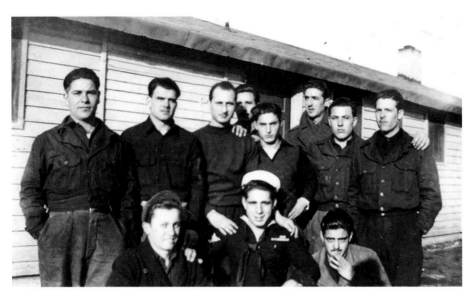

Giovanni D'Onofrio (third from left) and friends at Ogden Depot, courtesy of his children, Vincent, Orazio, and Janice.

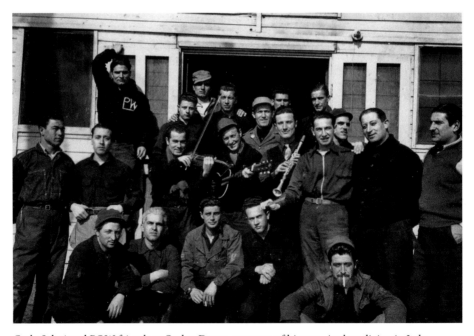

Carlo Selmi and POW friends at Ogden Depot, courtesy of his son, Andrea, living in Italy.

Life in the Camps

The maximum number of German POWs held in the continental US was 371,683 in May 1945. Italian POWs (continental US) reached a maximum of 51,156 in November 1944. Japanese POWs (continental US) reached a maximum of 5,413 in August 1945. There were POW camps in every state except Vermont, plus the territories of Hawaii and Alaska.

The POWs were placed into companies of 250 men each, eight companies to a compound (2,000 men), with two compounds at Ogden ASF Depot in 1943. Later, one compound at Ogden ASF Depot was composed of Italian Service Units while the other housed German POWs who were willing to work there. They were the first camp to work the two groups together, with Germans supervising Italians and the opposite.

Each base camp had a station hospital, staffed by both Americans and POWs. Utah ASF Depot station hospital had 100 beds. Since many POWs arrived in poor health due to long imprisonment and poor diet (both before and after imprisonment), that hospital admitted over 2,000 men by June 1944 after opening only eighteen months earlier.

Housing and furnishings at first met, and then exceeded the Geneva Convention requirements. Since the camps were in different locations, some utilized barracks, some hutments (smaller housing units) while the temporary and seasonal camps often used tents. The Geneva Convention required mattresses only for officers. Eventually, most permanent camps had mattresses, pillows and pillow cases on iron and wooden beds for enlisted men as well as officers.

General Hospitals, run by the Surgeon General of Army Service Forces (ASF), were in each region, utilizing a POW wing to facilitate security. In 1944, they became more specialized to receive all patients from theaters of operations, plus patients needing specialized treatment in the Zone of Interior.

Those station hospitals with airfields were overseen by the Air Surgeon of the Army Air Force (AAF). In 1944, Regional Hospitals (a new designation), station hospitals, and convalescent centers were now run by both the ASF and AAF. The Regional Hospitals were to serve as General Hospitals for Zone of Interior patients. These designations are rarely mentioned in the population lists in the National Archives.

Ogden Depot Hospital, courtesy of Special Collections Department, Stewart Library, Weber State University.

POW camp nurses at Ogden Depot Hospital, courtesy of Special Collections Department, Stewart Library, Weber State University.

The station hospitals were generally staffed with an American officer of the Medical Corps and three POW attendants with medical training. The surgical staff included an American medical officer, a nurse, an enlisted man and three POW attendants with medical training. POWs also served as lab technicians. The hospital mess was under the mess officer with a civilian nurse and a mess sergeant. It was staffed by two army mess sergeants, one POW mess sergeant and four POW cooks. Provisions were made for special diets.

Mental patients in Utah were sent to Bushnell General Hospital, UT while extreme cases were sent to Mason General Hospital, NY. Dental care was also provided at the station hospital for the POWs treating abscesses and doing extractions, fillings, and gum treatments. At Utah ASF Depot, over 17,000 dental cases were treated during the year of 1943-1944.

Upon arrival, the POWs were issued clothing and blankets which were maintained and replaced as needed. The Red Cross in New York was issued two pairs of blankets per man and a uniform that might be the dark blue with white PW lettering, or an old US Army uniform, plus the uniform he arrived wearing. Not many had overcoats, some came with English overcoats, black with a black diamond on the back.

The POWs were supposed to be adequately, comfortably, and properly clothed in accordance with the climate conditions in which they lived and worked. The War Department later determined that dark blue was a preferable color since it would not be mistaken for the American khaki. They were also provided with woolen underwear, cotton underwear, woolen socks and cotton socks, woolen shirts and cotton shirts, two pairs of trousers in either wool or denim, two cotton coats in wool or khaki, a wool overcoat, a raincoat, woolen caps and hats, cotton hats and caps, shoes and overshoes, gloves, and two heavy woolen blankets. When an item wore out, it was immediately replaced. The clothing was class X or class B, American issue.

Some camps had laundry facilities with machines while some had wash rooms where laundry was done by hand.

Education included language classes, history classes and clerical and equipment training. Supplies were provided for many art projects and newsletter production.

Newspapers were produced by the prisoners at most of the larger camps. There is a collection of Italian POW newsletters at Utah State University. There is a large collection of German POW newsletters at the Library of Congress. Many of these newsletters can be found at local colleges and historical societies.

Their food was the equivalent of that issued to American servicemen (type A field ration), according to the Geneva Convention, although substitutions were made to recognize ethnic preferences. The Italian POWs had an increase in rice, spaghetti, macaroni, noodles and pasta with decreases in meats and baked beans. Germans had an increase in potatoes and a decrease in beans. Meals were served three times daily. Special menus were prepared on Thanksgiving, Christmas, New Year's and other holidays. For many

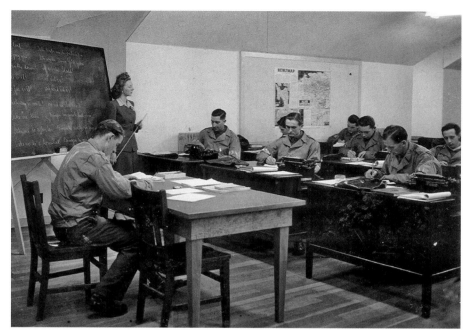

German Typing Class at Utah ASF Depot, courtesy of Special Collections Department, Stewart Library, Weber State University.

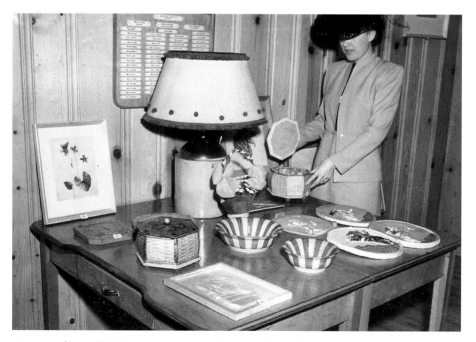

Courtesy of Special Collections Department, Stewart Library, Weber State University.

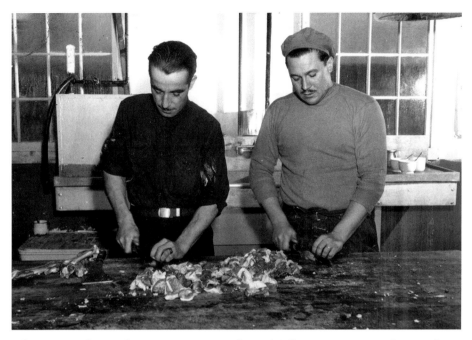

Italian POW cooks at Utah ASF Depot Courtesy of Special Collections Department, Stewart Library, Weber State University.

prisoners, these rations exceeded their military experience. The average prisoner at Utah ASF Depot gained fifteen pounds.

The POWs were their own cooks and bakers, paid the same wage as those working in all occupations both in and outside of the camps. However, each camp commander had some autonomy and, after the liberation of concentration camps in Germany, some camps restricted food allowances for POWs well below Geneva Convention. Hereford, TX, for example, is infamous for its dietary cuts in 1945.

Many services were available for POWs, some in accord with the Geneva Convention and some additional benefits. They included Canteens, camp stores where a POW could spend the pay (in coupons) he had earned working on such items as beer, cigarettes, and gold jewelry (high quality necklaces, wedding rings and rosaries were in high demand by the Italian POWs at Utah ASF Depot). The profits from the sales were returned to the POWs in the form of free beer, cigarettes, and theater tickets.

Some POW photos show the decorations (pin-ups) in their personal areas. These could include small pictures of national leaders along with flags or emblems, but large displays were limited to funerals and religious services.

Recreational supplies were provided for many sports, although soccer was most popular. Other equipment included baseball, softball, basketball, football, boxing, volleyball,

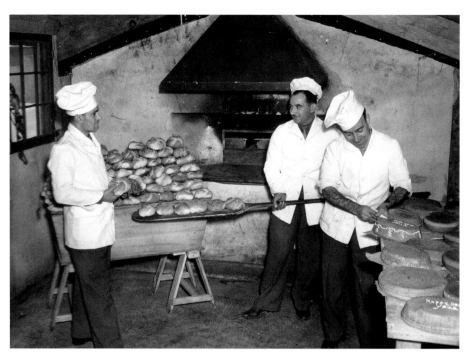

Ogden Depot Italian POW Bakery, courtesy of Special Collections Department, Stewart Library, Weber State University.

croquet, horse shoes, badminton, and table tennis. Many game sets were also provided for the POWs including dominoes, Chinese checkers, checkers, backgammon, India, bingo, chess, playing cards, etc. The POWs often constructed their own volleyball courts, baseball diamonds and soccer fields.

POW contacts with families and others included inspection visits from the Red Cross, YMCA, Swiss government, the Vatican, and other welfare organizations. Each POW was permitted two letters and one post card per week, written in ink (not pencil). Also, when necessary, one business letter per week. Special stationary was provided, so they were limited to the lines on the forms. Free mailing was applied to all letters, postcards, and parcels less than four pounds, addressed to or sent by a POW through the US Postal Service. Each POW was also allowed, at his own expense, one prepaid cable or telegram per month. In the event of a serious emergency (death or serious illness), and at the discretion of the base commander, more than one per month may be sent.

Incoming mail for Italian POWs from relatives in the US was enormous. In two or three months alone, 300-500 packages were received at Utah ASF Depot. The POWs sent many gifts to their relatives in this country and to those outside the continental US. Correspondence to POWs was permitted from anyone. However, POWs could only send

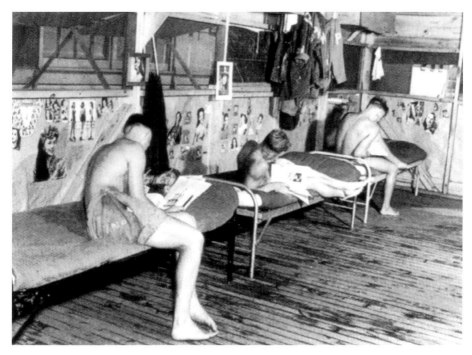

Barracks at Camp Atterbury, courtesy of Alessandro de Gaetano.

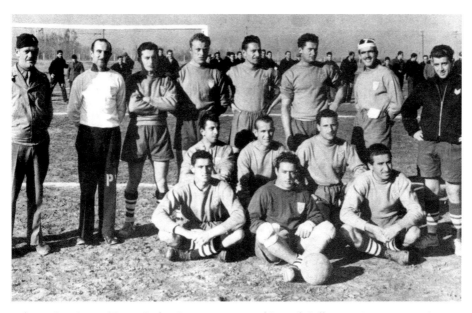

Italian POW Soccer Team, Ogden Depot, courtesy of Special Collections Department, Stewart Library, Weber State University.

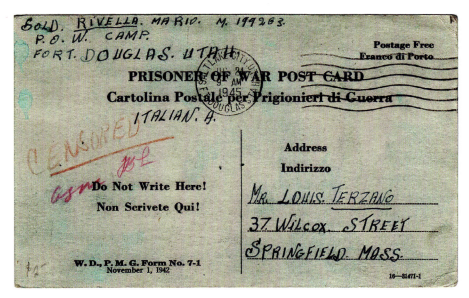

POW Postcards courtesy of Dennis H. Pack.

Life in the Camps

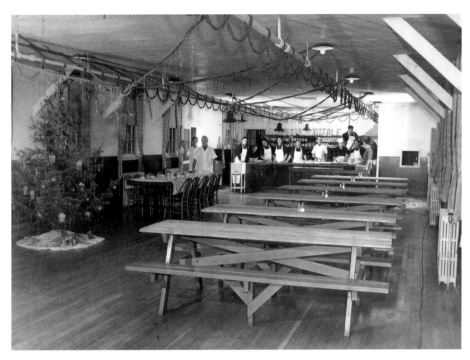

Utah ASF Mess at Christmas and ISU party, courtesy of Special Collections Department, Stewart Library, Weber State University.

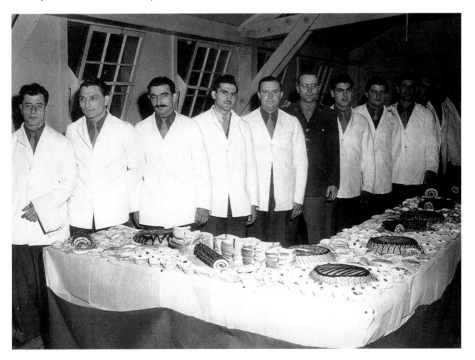

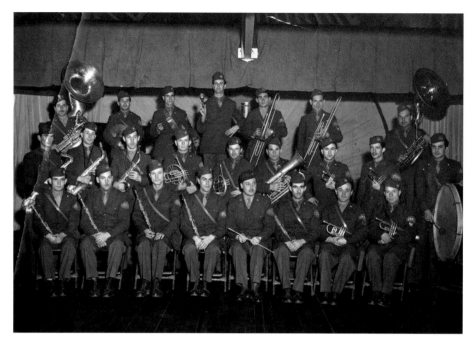
ISU Band at Utah USF Depot, courtesy of Andrea Selmi, son of Carlo Selmi, clarinet.

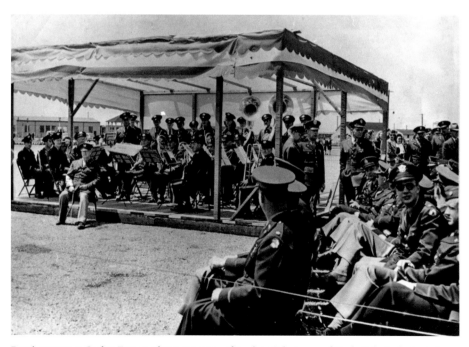
Band concert at Ogden Depot, photo courtesy of Andrea Selmi, son of Carlo Selmi, clarinet player in this band (3rd from left), living in Italy.

Life in the Camps 35

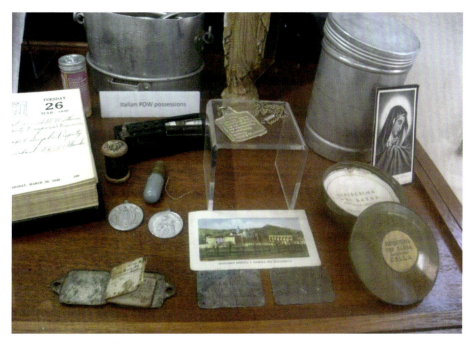

Artifacts from Camp Florence, courtesy of Florence, Arizona Information Center.

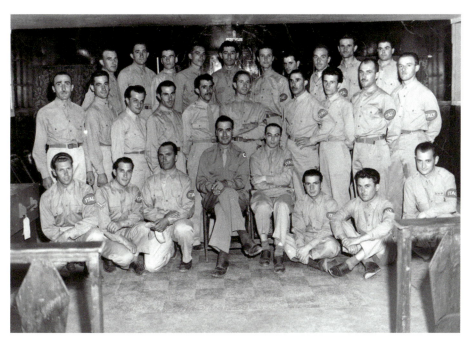

ISU at Utah ASF with Father Raphael Monteleone (Italian born US Army Chaplain), courtesy of Andrea Selmi.

and receive packages to and from family members such as wives, grandparents, parents, siblings, aunts, uncles, children, nieces and nephews.

Most camps had bands and/or orchestras made up of their POW population. At Ogden, UT, as at many other camps, concerts were held once a week. The orchestra also played for stage shows and gave monthly concerts. Many instruments were provided by the Catholic church, others were loaned by the Depot Quartermaster. At some camps, the local schools and communities provided instruments.

Religion was also a part of camp life with Catholic and Lutheran services held on Sundays, daily Catholic Mass in camps where a priest was part of the staff.

While POWs were not allowed to donate blood (prohibited by the PMGO and Geneva Convention), they were allowed to make voluntary contributions to specific organizations, such as the Red Cross and the YMCA. A minor political group at Utah ASF Depot, the Republicans, collected $80 for war bonds, offered to donate blood, and offered the money to the Infantile Paralysis Fund.

Escapes were expected and did occur at several locations. Most of them were short in duration and distance, usually ending with an easy capture or surrender since the object was just to get outside the fence for a while. Some were more serious, with bigger plans and groups of men, also usually ending in surrender. Just a couple of men were able to remain at large until many years after the war ended. No reports of sabotage or terrorism were ever associated with these escapes.

Papago Park was the location of the largest escape from an American POW camp. On 23 December 1944, twenty-five Germans tunneled out, including German U-boat commander Jürgen Wattenberg, through a 178-foot tunnel, heading for a river they expected to follow into Mexico. But the river was dry, even in the rainstorm that night. Wattenberg was the last to be captured, on 28 January 1945.

One of the Italian groups had been moved from Italy to Africa to Lordsburg, NM to Ogden, UT accompanied by a big brown dog, according to the Ogden historian.

POW work included occupations required for the maintenance of the camps, such as cooking, cleaning, clothing and shoe repairs, landscaping, etc. They also were hired out for canning and farming in the community, including pruning orchards and planting as well as harvesting. They also worked on dams, railroads, orchards, mining, quarrying, and forestry. The businesses and farmers paid the government a minimum wage and the POWs were paid eighty cents a day, comparable to the wage for a civilian day laborer.

Even the Ogden Chamber of Commerce hired POWs. Italian POWs at Fort Monmouth, NJ were making violins.

Other POWs were working on occupations labeled military, such as at hospitals, supply offices, post exchanges, construction, dying uniforms, landscaping, and woodworking.

Sometimes POWs worked on community service projects outside the camp. The Catholic

WAR DEPARTMENT

CONTRACT FOR LABOR OF PRISONERS OF WAR

Contract No. W- 03-044 -pmg- 76

PRISONER OF WAR CAMP: Monticello, Arkansas

(This contract is authorized by and has been negotiated under the First War Powers Act, 1941, and Executive Order No. 9001)

THIS CONTRACT, entered into this 19th day of June 1945, between the UNITED STATES OF AMERICA hereinafter referred to as the Government, represented by the contracting officer executing this contract and Ozark Badger Lumber Company

(*) A corporation organized under the laws of Arkansas whose address is Wilmar, Arkansas hereinafter called the contractor, WITNESSETH, that the parties mutually agree as follows:

1. LABOR.—The Government will furnish the Contractor the labor of prisoners of war in the following amount:
 (a) Number of men each work day 16
 (b) Number of work days 78
 (c) Labor will be furnished commencing on or about 20 June 1945 and ending on or about 20 Sept. 45
 (d) Normal work day will consist of 10 hours of labor (Excluding lunch and travel time).
 (e) The address of the work site is Vicinity of Wilmar, Arkansas
 (f) Type of work is Cutting of Pine Timber (Faller)

2. TRANSPORTATION, TOOLS, ETC.
 (a) Transportation for prisoners of war and guards from the camp to the work site and return to the camp will be furnished by the Contractor
 (b) Distance between camp and work site is 13 miles.
 (c) Tools and equipment will be furnished by the Contractor
 (d) Maintenance of tools and equipment will be provided by the Contractor
 (e) Other items None

3. COMPENSATION.—The Contractor will pay to the Government compensation at the following rates:
 (a) Labor $2.50 per 1000 ft. 16 prisoners cutting 32,000 ft. = $80.00 per day
 $80.00 x 78 days = $6,240.00
 (b) Transportation Furnished by Contractor at his expense
 (c) Other items None

4. ALLOWANCES.—The Government will grant the Contractor allowances as follows:
 (a) Transportation None
 (b) Other items None

5. VALUE OF CONTRACT (Estimated)
 Gross charges $ 6,240.00 Allowances $ None Net charges $ 6,240.00

6. If the Contractor fails to utilize fully the labor of prisoners of war in accordance with paragraph 1, above, the loss and damage to the Government resulting from the reduction in essential war production for which such labor could have been utilized will be impossible to determine, and in place thereof, the Contractor shall pay to the Government the sum of $1.50 per day for each prisoner whose labor is not so utilized, unless the failure so to utilize such labor was due to unusually severe weather, acts of God, or other unforeseeable causes clearly beyond the control of the Contractor.

7. As a condition to the execution of this contract, the Contractor has furnished security for payment to the War Department in the form of (†) CASH DEPOSIT—BANK GUARANTEE—SURETY BOND, to guarantee the satisfactory settlement of accounts due for labor furnished under the provisions of this contract. The total security for payment required for this contract is $ 6,240.00 of which $ None is represented by the Contractor's investment in branch camp construction, and $ 1040.00 is in the form indicated above, satisfactory evidence of which is attached hereto. (Certificate of surety, bank guarantee, or escrow agreement for cash deposits.)

8. The Government will furnish meals for prisoners and guards unless otherwise provided in this contract.

9. The Contractor agrees to furnish adequate training instruction and work supervision.

10. The Contractor will not be responsible for disability compensation or medical care for the prisoners of war.

11. The Contractor agrees to make payment to the Contracting Officer, by certified or cashier's check, or United States Post Office money order, payable to the Treasurer of the United States, within 10 days after receipt of bill or invoice.

(*) Describe as: "An individual trading as * * *"; "A partnership consisting of * * *"; or, "A corporation organized under the laws of the State of * * *."
(†) Strike out types of security for payment not applicable.

WD AGO FORM 19-19
1 MAY 1945

Courtesy of Michael Pomeroy.

-2-

2. Conditions of employment offered by this employer are not less favorable than those for other workers in the same or similar employment at this establishment or farm, or less favorable than those prevailing in the locality for similar work.

3. The prevailing wage, or price per unit, certified above is that paid to free labor in this locality for this type of work. (For agricultural work, the prevailing wage, or price per unit, certified by the State Director of Extension may be based on public hearings conducted by County Farm Wage Boards.)

4. It has been impossible to secure the necessary workers for this employer through an active campaign of recruitment which has taken into account not only all persons normally engaged in the activities listed above, but also potential workers from other fields of activities.

5. The employer is willing to use through contract with the Government, the labor of prisoners of war detained by the United States of America and in the custody of the War Department. It is the understanding of the undersigned that such contract will follow substantially War Department contract form for prisoners of war and that amount to be paid and conditions stated in the contract will be in accord with those certified in this statement.

INDORSEMENTS

1. Approval of the above certificate is recommended:

Louise C Thompson (signature) Manager (title)

6-19-1945 (date) 308 North Main St. Monticello, Arkansas (address)

II. The above certificate is approved:

Alvad Dunn (signature) Deputy Regional Director (title)

6-23-45 (date) 1600 Fidelity Bldg., Kansas City 6, Mo. (address)

III. The labor certified above has been determined to fall in priority 2

Denton O. Rushing (signature) State Manpower Director (title)

5-21-45 (date) Old Post Office Bldg., Little Rock, Arkansas (address)

Courtesy of Michael Pomeroy.

```
                    CERTIFICATION OF NEED FOR EMPLOYMENT
                              OF PRISONERS OF WAR

To: Commanding General,
      8th    Service Command
    Attention:   Commanding Officer, Monticello Prisoner of War Camp
    The          War Manpower Commission                     certifies that:

    1. The employer to whom this certificate is issued and whose name, address
and place of business are listed below, has need for the labor hereinafter
described for essential work at his establishment or farm.

    a. Name of employer    Ozark Badger Lumber Company
    b. Address of employer  Wilmar, Arkansas

    c. Type of business     cutting of pine timber
    d. Location of work (if not at above address)  vicinity of Wilmar, Arkansas

    e. Labor needed: From    6-20-1945       to      9-20-1945
                              (date)                   (date)
        For period of approximately   3 months     days-months
                                        (number)    (cross out one)
    f. Detail of type of work, number of prisoners, and wage rates:

    | Number needed | Occ. Title and Code for Industry or Nature of Work Done for Agric. | Man Days or Hours Required | Unit of Work | Prevailing wage per unit |
    |---|---|---|---|---|
    | 16 | Faller - 6-30.140 (cutting pine logs) | 416 man days per mo. | by 1000 ft. | $2.50 per 1000 ft. |

These prisoners are to be used only at such times as soil and weather conditions prevent
their use in agriculture
    g. If at piece rate, average
        civilian labor will complete   2 to 3    units per day.
                                       (number)
    h. The employer usually furnished the following services free of charge
        to civilian labor: *
                         tools - transportation
    i. The employer    will       supply transportation to and from the
                   (will or will not)
        prisoner-of-war enclosure.
    j. The employer   will not    provide the noonday meal.
                   (will or will not)
    k. Length of work day in this locality
        for this type of work is customarily        8         hours.
                                                (number)
    *  Enter, if appropriate, one or more of the following: transportation to
       and from work; noon meal; housing accommodations.
```

Courtesy of Michael Pomeroy.

12. The Contractor agrees to maintain conditions of employment in conformity with War Department regulations applicable to the employment of prisoners of war on the type of work described in this contract. The Contractor will comply with all written directions of the Government for the correction or improvement of conditions of employment found by the Government to be in violation of the Geneva Convention and for security and safety measures. The Contractor acknowledges the receipt of an "Instructions to the Contractor for Prisoner-of-War Labor" and agrees to observe these instructions and any amendments or additions that the Government may make in such instructions.

13. The Contractor agrees that duly accredited representatives of the Government and the protecting power will at all times have access to the site of the work in order to observe the conditions of employment.

14. The Contractor agrees that he has no authority to impose disciplinary measures on prisoners of war.

15. The Contractor agrees to permit the Government to maintain at the site of the work such guards and other security measures as may be found by the Government to be desirable or necessary, and to cooperate fully with the Government in all security measures.

16. If it be found by the Government that the Contractor has suffered damages to his property or to property for which he is responsible to a third party, uncompensated by insurance, arising out of the employment of prisoners of war, and not the result of fault or negligence of the Contractor, which are caused by the willful misconduct of prisoners, the Government (without prejudice to any other rights which the Contractor may have) will allow the amount of such damages as a credit against payments otherwise due from the Contractor hereunder; but no such credit shall be taken without the specific approval of the Government, nor shall the liability of the Government under this paragraph for any such damages exceed the unpaid amounts due from the Contractor at the time he files a claim for property damage and from amounts which subsequently become due under the terms of this contract.

17. This contract may be terminated by either party, with or without cause, by 10 days' notice in writing. In event of termination the Contractor will pay to the Government, at the rates herein set forth, all charges accrued up to the effective date of termination.

18. No member of or delegate to Congress or resident commissioner shall be admitted to any share or part of this contract or to any benefit that may arise therefrom, but this provision shall not be construed to extend to this contract if made with a corporation for its general benefit.

19. The Contractor warrants that he has not employed any person to solicit or secure this contract upon any agreement for a commission, percentage, brokerage, or contingent fee. Breach of this warranty shall give the Government the right to annul the contract, or at its option, to recover from the Contractor the amount of such commission, percentage, brokerage, or contingent fee, in addition to the consideration herein set forth. This warranty shall not apply to commissions payable by the Contractor upon contracts secured or made through bona fide established commercial agencies maintained by the Contractor for the purpose of doing business.

20. Except as otherwise specifically provided in this contract, all disputes concerning questions of fact which may arise under this contract, and which are not disposed of by mutual agreement, shall be decided by the Contracting Officer, who shall reduce his decision to writing and mail a copy thereof to the Contractor. Within 30 days from said mailing the Contractor may appeal to the Secretary of War, whose decision or that of his designated representative, representatives, or board shall be final and conclusive upon the parties hereto. Pending decision of a dispute hereunder the Contractor shall diligently proceed with the performance of this contract.

21. Except for the original signing of this contract, the term "Contracting Officer" as used herein shall include his duly appointed successor or his authorized representative.

22. The "Certification of Need for Employment of Prisoners of War" attached to this contract is for the information and guidance of the appropriate contracting parties and is not a part of this contract.

23. The following changes were made, and addenda attached, to this contract before it was signed by the parties hereto:

Payment to the Contracting Officer by certified or cashier's check or U. S. money order payable to the Treasurer of the United States will be made by the Contractor on or about the tenth of each month for labor furnished during the preceding month.

IN WITNESS WHEREOF, the parties hereto have executed this contract on the day and year first above written.

Witness: Doris H. Strachan
Monticello, Ark.
(Address)

THE UNITED STATES OF AMERICA:
By J. H. Kuttner
JAMES H. KUTTNER
Colonel, Infantry
Contracting Officer.

Witness: Elizabeth W. Chandler
Monticello, Arkansas
(Address)

Contractor:
OZARK BADGER LUMBER COMPANY
By L. K. Pomeroy
L. K. POMEROY, President

I, E. P. Connor, Assistant certify that I am the Secretary of the Corporation named as Contractor herein; that L. K. Pomeroy who signed this contract on behalf of the Contractor was then President of said Corporation; that said contract was duly signed for and on behalf of said Corporation by authority of its governing body and is within the scope of its corporate powers.

IN WITNESS WHEREOF, I have hereunto affixed my hand and the seal of said corporation this 16 day of July, 1945.

E. P. Connor
Assistant Secretary.

Courtesy of Michael Pomeroy.

Catholic Church of St. Mary's in Umbarger, TX. Photo from John Saffell.

Church of St. Mary's in Umbarger, TX was beautifully decorated with murals and other artwork by Italian POWs from nearby Camp Hereford.

The POWs were paid at a rate of $3 per month if they did work (enlisted) or $24 a month for officers who were not allowed to work. Those who did work were paid $0.80-1.20 per day depending on if working for local farmers or private companies. This was paid to them in coupons they could use at the canteen, although ISU members could receive one-third of their pay in cash to use in town. An office of the Italian Army which made sure all the former POWs received their due pay was opened at the end of the war and continued until very recently. I worked in their offices in 2004 and was able to obtain records of transfers from camp to camp and the health record for a POW (with authorization from his son). The Geneva Convention required that officers be separated.

Italian Service Units

The fall of Mussolini and resultant change in that government's position in the war from Axis to Allied required some changes regarding Italian POWs. It was quickly determined that releasing them would not be the best solution. The original idea of Italian POWs being organized into units to provide labor similar to the Civilian Conservation Corps (CCC) was first proposed by the US Secretary of War in October 1943. This would require separation of Fascist Italian POWs from those willing to work for the war effort as co-belligerents. They would be:

> attached to and placed under the command of the US Army ... Therefore, the plan included these features: (1) Italian prisoners would be organized into numbered Italian service companies consisting of 5 officers and 177 enlisted men ... (4) An Italian service unit headquarters would be established under ASF and would be commanded by an American officer ... The new plan provided for Italian Service Units (ISUs) to be organized from volunteer Italian PW officers, non-commissioned officers, and enlisted men under approved tables of organization and equipment, less weapons. Initially, two US Army officers and 10 enlisted men were to be attached to each unit for supervision; but these were to be reduced, consistent with efficiency and security, to a minimum of one officer and five enlisted men.

The ranking Italian General over the new ISU on 26 January 1944, Claudio Trezzani, states,

> The units should be commanded by Italian officers, in this proportion; one first or second lieutenant for 30 to 35 enlisted men (platoon), one captain for 4 platoons (company), one senior officer for 3 companies (battalion), one colonel for 3 battalions (regiment).

That letter is followed in the Italian Army file at Stato Maggiore Esercito in Rome by an apparent American response with no name or date attached stating, "It is contemplated organizing Italian Service Units according to American tables of organization with Italian military personnel in all authorized positions, American officers and enlisted men in the smallest possible numbers will be attached as custodians, for liaison, to issue operational directives, sign payrolls and charges, and have general responsibility for the units to

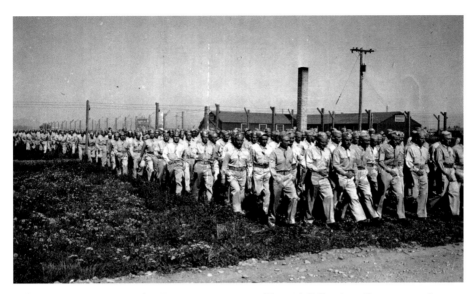

Italian Service Units at Utah ASF Depot, courtesy of Special Collections Department, Stewart Library, Weber State University.

higher American authority." Italian Generals Frattini and De Simone were moved to ISU headquarters at Fort Wadsworth from Camp Monticello.

The ISU program was under the command of Brig. General J.M. Eager, from the PMGO. The ASF retained the responsibilities of plans, policies and procedures as well as the designation and strength of units and training programs and doctrines. Each unit had American personnel of one officer and five enlisted men at a minimum. Service commands were responsible for all other ISU functions and activities. Interviews with former translators assigned to those units confirmed that one American NCO was a translator for the unit.

The ISU had increased responsibilities resulting in increased privileges for the sixty-five percent of Italian POWs who signed up to serve in Italian Service Units. The new units were activated progressively with 600 POWs organized in the first week of March 1944, 1,000 for the first two weeks of April, 3,000 the third week in April, and 4,000 each succeeding week until completed. While a letter was sent to the camps from Badoglio in Rome, it was vague and general, and the Italian king never wrote on the subject. This left many men in confusion as to the best course of action. Their families were in German occupied Italy and many feared repercussions for such a visible support of their former enemy. The screening from ISU to POW and reverse was continuous to ensure that only the most cooperative POWs were allowed the privileges of the ISU.

ISU units were held in separate camps from Italian POWs. Those POWs who did not join the ISU were classified as Fascist. Instruction in English was stressed in these new units, while the same housing and wages applied, with the addition of $0.10 a day for a

gratuitous allowance. Two-thirds of the wage was paid in coupons and one-third in cash. Rules against fraternization between members of ISU and American military did not apply. ISU service clubs were created to give them greater access to reading materials and a quiet place to relax since they did not have access to the US Army clubs. Dances and other special events were organized through the ISU service clubs.

Training programs for ISU were the same as for American personnel on similar jobs, less tactics and weapons training.

Work restrictions imposed by Geneva Convention were lifted with the consent of the Badoglio government of Italy, except for combat, work at ports of embarkation within continental US, and work with explosives. Their efforts released US personnel for overseas duties and helped to bring about the successful conclusion of the war.

ISU units began to ship to the European Theater to assist with support and supply from Africa and into Italy as part of the liberation of Italy in the following theaters of operation: North Africa, Eastern Europe and the Mediterranean. Apparently, some of these units were moved overseas at the discretion of the ISU command and the PMGO was not informed.

Mail restrictions were reduced to the same standards as American personnel for domestic correspondence. Regulations were the same as POWs for international mail. The new ISU uniforms were the same khaki as US uniforms, with a patch (Italy) on the left shoulder. At least one man was court-martialed for removing the Italian patch on a night out on the town, leading to accusations of being AWOL. However, he was simply reprimanded instead of sent to a POW camp.

The POWs and their employers and guards were not supposed to fraternize but, of course, they did. While some of the initial contact was antagonistic, many friendships and romances resulted.

ISU men were permitted weekend passes when signed out by a sponsor. Many Italian communities utilized these privileges to give some of the ISU men a family gathering, social activity, or dance. Some of the dances at the ISU service club included invitations to young women in the community.

Additionally, ISU members were given day passes into town for movies, dances, and for plain sightseeing. In Ogden, buses were used to transport ISU men from their barracks to St. Joseph's Catholic Church in downtown Ogden for dances. These dances were organized so that one night a week was for officers and three nights a week for enlisted men. Decorating was done by the ISU and they provided the orchestra on Thursday nights. The jukebox and games were provided by Catholic groups in Ogden and Salt Lake City. Of course, the greatest attraction was meeting and dancing with American girls.

Some of these meetings resulted in marriages. The POWs could not marry, but once engaged and returned (by June 1946), the troop transports bringing GIs home were taking these women with their escorts to Italy with the proper paperwork to marry so they could return to the US with their new husbands. Five of these couples settled in Ogden, UT.

Some of these meetings had unhappy endings. The local culture was against marrying a man of a different ethnic or religious background, plus some families feared that their girls would follow the men to Italy and never return. So those romances were discouraged, even after they created children. Some of those children were adopted out, while some stayed with their mothers who married other men in the US after the war. Some of those children are sought their Italian families all their lives. Fortunately, we have assisted with some happy reunions.

Public opinion varied as shown in a variety of newspapers from those years. There were some escapes, usually associated with meeting a girl outside the camp for reasons that had nothing to do with national security.

The Italian POWs held a unique position as both POWs and allies that created different experiences for them than for their German counterparts. In Utah and other ISU locations, these differences meant more opportunities to not only work with the residents, but also to socialize with them. The resulting friendships (and some marriages) show the positive results of their experiences under very difficult circumstances.

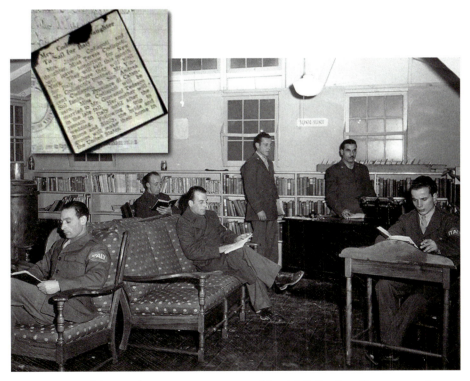

Italian Service Club at Utah ASF Depot, courtesy of Special Collections Department, Stewart Library, Weber State University.

Inset: Wedding announcement for former POW. Photo by author at Camp Atterbury Museum.

Death in the Camps

A total of 1,075 burials were held, including 880 Germans (this includes three Russians, four Austrians, one Yugoslavian, one Czech, one Turk) 172 Italians and 23 Japanese (includes one Korean), out of 1,076 POWs who died while held in the US during World War II.

Many of the larger camps had their own cemeteries. After the war, the cemeteries from those camps which had been closed and some other locations, were moved to national cemeteries to provide the perpetual care demanded by the Geneva Convention.

While most of the headstones were standard issue for US military, there were some exceptions. At Fort Douglas, Eilert's stone was put up by the POWs with the permission of the camp commander and paid for by the POWs.

The funeral services were often accompanied by Americans as well as POWs, sometimes also a POW choir and/or band and a symbolic series of shots fired by a military guard.

Rumors insist that most of the POWs who died here were shipped home. The truth is that the US Government was willing to ship them, if the family bore the cost. Of course, most of the families were simply unable to bear that burden at the end of a war they lost. Only one Italian, Renato Facchini, was returned to Italy before February 1947, while Francesco Erriquez was returned to Italy in 2011. Apparently, none of the Germans were returned since the names in the original reports match the current cemetery records.

Some of the deaths were accidents in the course of work or recreation. Others were later deemed murders by Nazi extremists. Some were suicides, particularly at the end of the war.

One example of a murder was the Papago Park incident mentioned earlier, where a German POW was murdered by his former comrades for revealing military secrets to the Allies. In exchange for the information, Americans had promised to never place him in a camp with German submariners, but it happened, and he was killed within hours. The men who killed him, although they followed the same directives followed by all captured military, were sentenced to death and hanged at Fort Leavenworth after the end of the war. Information gained at Fort Hunt was used later in the murder trials of those naval POWs.

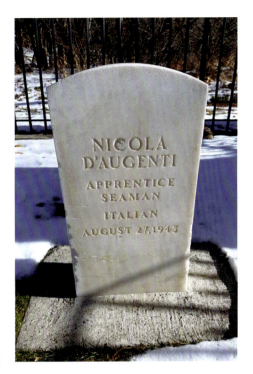

Right: Fort Douglas, UT, photo by author.

Below: Fort Douglas Cemetery, photo by author.

Returning Home (1945-46)

Certain camps were designated as separation centers (like Florence, AZ) and the POWs were moved through them, then on to ports of embarkation on both coasts for the trip home. The first returned were the Italian officers as co-belligerents. The next group was the ISU members, then the rest.

The Geneva Convention of 1929 required that POWs be returned home at the end of a war. However, the large numbers provided some logistics problems. Generally, troop ships bringing US troops home turned around full of POWs. However, treaties with all countries required some of the POWs (excluding ISU) to be sent to France, the USSR and Great Britain to assist with reconstruction efforts. Some of the men in Great Britain and France worked there for as long as four years before returning home. The USSR finally released the surviving prisoners ten years later.

Warnings were made regarding German POWs scheduled to be sent to the USSR. It was only after the first group was killed on the dock by the crew of the Soviet vessel which met them that other arrangements were made for those men.

Some POWs claimed status as US citizens and requested permission to stay, but were returned to avoid the legal complications.

Some locations requested that their POWs stay long enough to complete the fall harvest and that was permitted when it could be arranged. The last POWs were repatriated (out of the US) by 30 June 1946 except for 141 Germans, twenty Italians, and one Japanese serving sentences in US penal institutions, along with two Germans who remained undiscovered many years later.

A large number of ports were utilized as departure points for the returning POWs. They included:

Los Angeles, CA
Charleston, SC
New Orleans, LA
Hampton Roads, VA
New York, NY

Boston, MA
San Francisco, CA
Seattle, WA
Halifax, Nova Scotia

Those same troop vessels were used to transport American fiancés of POWs to Naples and Genoa. These American war brides often spent a few months in Italy to complete the red tape required for a marriage there and assisted their new families in rebuilding. They then brought their husbands home to America. These stories were shared by Pat and Maria Pisani and by Beth Giordana, war brides and American girls who made the trip to Italy to marry their former POW husbands.

Part of the logistics meant that after the US troops returned home, their European war brides and families were shipped home on the same troop ships, slightly modified to accommodate families with small children. Be sure to see the Cary Grant movie, *I Was a Male War Bride*, more funny than factual, but it is based on the real transport of war brides from Europe to America.

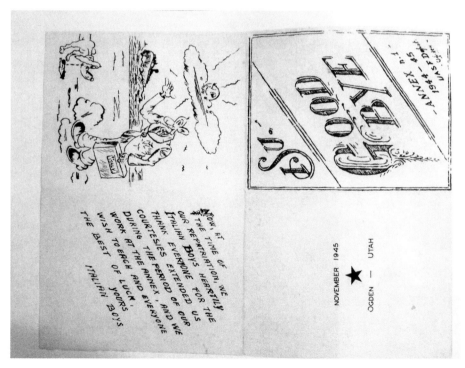

This goodbye note from the Italian Boys at Ogden Depot was saved by Mario Saggese, one of those boys, and used here courtesy of his daughter, living in the United States.

Wilson Longo (named for Woodrow Wilson) was born and died in Bellosguardo, Italy. He was a prisoner at Utah ASF. His cousin, Barbara, provided this photo and information.

Other former POWs made the move to live in the US from ten to twenty years later. They settled in areas where they had worked as POWs, apparently in nearly every location in the country. Only local newspapers have these stories, so it is difficult to get statistics. I recently found an article, "Returning to America: German Prisoners of War and the American Experience" by Barbara Schmitter Heisler, details in the bibliography.

The trip to marry in Italy was made by a young woman from Louisville, KY who had met her husband when he was a prisoner at Camp Atterbury, Indiana. They met at a dance sponsored by the local Italian-American community for the Italian POWs. I met this lovely woman at a POW Reunion at Camp Atterbury in 2010 along with her children. They were regular attendees at this annual event and had wonderful stories to share. They also have a display at the Camp Atterbury Museum, across the road from the main gate to Camp Atterbury, now a reserve military training facility.

After the War

Some of the camps were determined to be surplus, so the property was auctioned off and the land was sold or transferred to another federal or state agency. This was a thorough process, leaving behind very little in the way of buildings to mark the former camps today.

The POW personnel records were returned to the nations from which the prisoners were taken in 1955. The German records are now available at:

Deutsche Dienstelle (WASt)
Postfach 51 06 57
D-13400 Berlin
Germany

The Italian records are now available at:

Ministero della Difesa
via Mattia Battistini, 113, 7 Piano
00167 Roma
Italy

The Japanese records are now available at:

Military History Department National Institute for Defense Studies
2-2-1 Nakameguro, Meguro-ku
Tokyo, 153-8648
Japan

The former POWs held in the US mostly held good memories of their time here. Some returned to become US citizens, like Ernst Bulkat who lived in Orem, UT. Information on them can usually be found in local papers in the 1970s and 1980s when local news groups interviewed them in a resurgence of interest in the WWII history of the area.

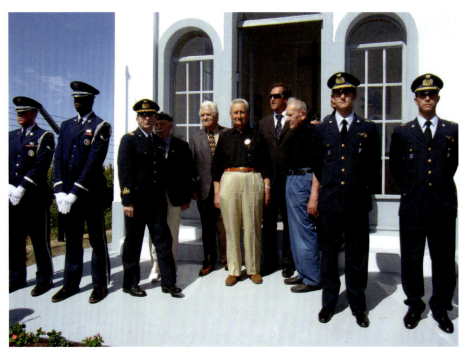

This photo was taken at the 2009 reunion at Camp Hereford, TX. The US Army is on the left, the former POWs center, and the Italian Air Force on the right. Photo by John Saffell of these men in front of the Chapel built by Italian POWs.

Some former POWs returned as tourists to show their families where they had spent part of the war. Some POW groups even returned for reunions, to share a ceremony and lots of memories.

Some diaries and recollections have been published by former POWs. See Heino R. Erichsen, *The Reluctant Warrior: Former German POW Finds Peace in Texas* for the story of a man who later became a US Citizen. The grandson of one of the Italian generals, Maurizio Parri, published his grandfather's war time diaries in Il *Giuramento; Generale a El Alamein, prigioniero in America (1942-1945)*.

Some former POWs have been gracious about allowing interviews at reunions, such as Adriano Angerilli, Enzio Luciolli, Giuseppe Margotilli, Fernando Togni (pictured above). Some of the former, guards, prisoners and their families have become available for interviews using email, like Ernst Bulkat, Mario Iannantuoni and August Orsini. On other occasions I am able to interview the children or grandchildren of a former POW in Italy or the US.

In 2009, one of the last reunions of former POWs visited the Chapel built by POWs at Camp Hereford, TX. This is indicative of a growing awareness that these memories and relationships must be preserved through reunions, books, lectures and movies.

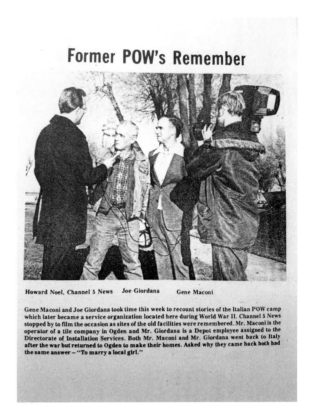

Courtesy of Special Collections Department, Stewart Library, Weber State University.

Some local magazines and newspapers have done stories on the camps and published interviews with former POWs returning to visit, or who had moved back to the area where they had been imprisoned. Some of these have been preserved by the newspaper, some by local historians, colleges, and historical societies.

A documentary video, *Prisoners in Paradise*, DVD, directed by Camilla Calamandrei, tells some of the stories of former Italian POWs, who are now a couple living in Utah.

Some local TV stations conducted interviews with surviving former POWs living in their communities in the 1970s and 1980s, like KUED and KSL in Salt Lake City, UT. Some local colleges (Special Collections, Stewart Library, Weber State University), created video archives containing interviews of former POWs and their families and former guards and other employees who interacted with POWs.

Some former POWs, guards, and their families donated their diaries and photos to local historical societies, like Drew County Historical Museum in Monticello, Arkansas. Some donated to the National Archives (NARA) in College Park, Maryland. Some donated to the Stato Maggiore Esercito in Rome, Italy. I expect more will be found in local colleges and libraries in America, Italy, and Germany.

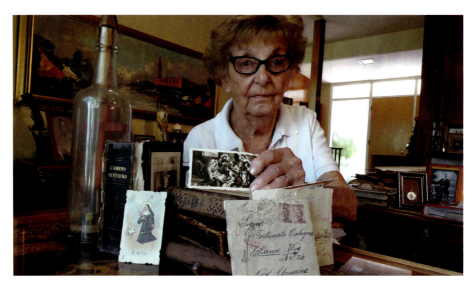

Mary Ravarino with photos and letters from the Italian POWs who worked on her family's farm in Salt Lake City area. Photo courtesy of Italian Center of the West (UtahCulturalNews.com).

Former guards, like Thomas Todaro and Peter A. Pulia, Sr. also shared their memories in interviews and photos. Some, like Ralph Storm, wrote books about their experiences with POWs.

Even today, I receive emails from the children and grandchildren of former POWs who want to learn more about the experiences of being a POW in the US and hope to locate records regarding their work, health, and transfers. Most of these former POWs do not or did not talk about their experiences. Mario Turrini only told his children that Hawaii was nice, no comment on his service in Greece, Tunisia, or his experiences at the other camps where he was held in the US.

Some of these letters come from Italy, but some also come from England, Australia, and the United States where these men took their families after the war.

These memories can assist us in planning for the future, promoting the preservation of photos and artifacts from the POW camps. Preservation of these memories can also be achieved by conducting interviews of surviving former POWs and their guards, and members of the community.

These memories and memorabilia can be used to educate public about the policies and experiences of WWII and to promote the good treatment of future POWs.

POW Camps by Location

There were 1,204 Prisoner of War Camps, Italian Service Unit Camps, and Prisoner of War Hospitals in the US.

The camp lists at NARA shows several APO addresses in place of camp names. Judging by the dates, these were located in the Philippines, Hawaii, and New Caledonia.

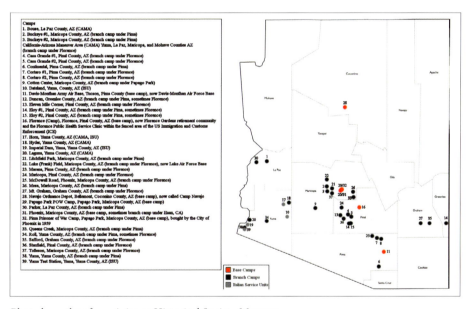

Photo by author from Arizona Historical Society Museum.

In Arizona, there were at least 12,149 German and 7,255 Italian POWS in thirty-nine POW camps as follows:

Bouse, La Paz County, AZ (part of the California-Arizona Manuever Area (CAMA)). These men supplied support services for the US Army training at CAMA. The population numbers were included under CAMA on the reports.

Buckeye #1, Maricopa County, AZ (branch camp under Pima). This camp was built by February 1944. In May 1944 it was home to 655 Italian POWs at its maximum. In January 1945, it was home to 725 German POWs at its maximum. Their work was primarily agricultural.

Buckeye #2, Maricopa County, AZ (branch camp under Pima). This camp was built in November 1944. In November 1945, held a maximum of 250 German POWs. It was part of CAMA.

California-Arizona Maneuver Area (CAMA), Los Angeles, San Bernardino, Imperial and Riverside Counties, AZ; Yuma, La Paz, Maricopa, and Mohave Counties, AZ; and Clark County, NV (branch camp under Florence). This was the area organized and run by General Patton to train US soldiers to fight in the North African desert. The summer heat was brutal, and training was so difficult that it was said to be more physically difficult than actual combat in North Africa.

Casa Grande #1, Pinal County, AZ (branch camp under Florence). This camp opened in February 1944. The maximum number of Italian POWs here was 325 in August 1944. The maximum number of German POWs here was 1,025 in May 1945. The work was both military and agricultural.

Casa Grande #2, Pinal County, AZ (branch camp under Florence). This camp opened in October 1945. The maximum number of German POWs was 226 in October 1945.

Continental, Pima County, AZ (branch camp under Pima). This camp was built in November 1944. At maximum, it housed 282 German POWs. Their work was agricultural.

Cortaro #1, Pima County, AZ (branch camp under Florence). This camp was opened in February 1944. The maximum Italian POW population was 1,038 in April 1944. The maximum German POW population was 872 in June 1945. Their work was agricultural and military.

Cortaro #2, Pima County, AZ (branch camp under Florence). The population was probably a portion of its sister camp's above since it did not have a separate listing on the population lists at NARA.

Cotton Center, Maricopa County, AZ (branch camp under Papago Park). This camp opened in January 1946. The maximum population was 226 German POWs in January 1946.

Dateland, Yuma, County, AZ. This camp was listed as the location of an Italian Service Unit (ISU). They may have been working on the All-American Canal or at Imperial Dam, but probably not doing agricultural work because they were more trusted than POWs.

Davis-Monthan Army Air Base, Tucson, Pima County (base camp), now Davis-Monthan Air Force Base. This POW camp opened in May 1945. At maximum, it was home to 233 German POWs in August 1945, doing military work (probably landscaping and supply at the airfield).

Duncan, Graham County, AZ (branch camp under Pima, sometimes Florence). This camp opened in October 1944. At maximum, it held 250 German POWs in September 1945. They worked in agriculture.

Eleven Mile Corner, Pinal County, AZ (branch camp under Florence). This camp opened in January 1944. It was home to 500 German POWs in May 1945, doing agricultural and military work.

Eloy #1, Pinal County, AZ (branch camp under Pima, sometimes Florence). This camp opened in February 1944. The maximum population was 848 German POWS in November 1944. They were doing agricultural work.

Eloy #2, Pinal County, AZ (branch camp under Pima, sometimes Florence). This camp opened in February 1944. The maximum Italian POW population was 292 Italians in July 1944. The maximum German POW population was 1,703 Germans in June 1945. The work was agricultural and military.

Florence (Camp), Florence, Pinal County, AZ (base camp), now Florence Gardens retirement community and the Florence Public Health Service Clinic within the fenced area of the US Immigration and Customs Enforcement (ICE). This camp opened in August 1943. The maximum population was 7,255 Italian POWs in December 1943, 12,772 German POWs in June 1945, and two Japanese POWs in June 1944. Their work was agricultural and military. This location was also a separation center, the location were POWs were processed to leave for home at the end of the war.

Horn, Yuma County, AZ (ISU). This was part of CAMA. These men supplied support services for the US Army training at CAMA. The population numbers were included under CAMA on the reports.

Hyder, Yuma County, AZ. This was part of CAMA. These men supplied support services for the US Army training at CAMA. The population numbers were included under CAMA on the reports.

Imperial Dam, Yuma, Yuma County, AZ. This was part of CAMA and was listed as the location of an Italian Service Unit (ISU). The population numbers were included under CAMA on the reports.

Laguna, Yuma County, AZ. This was part of CAMA. These men supplied support services for the US Army training at CAMA. The population numbers were included under CAMA on the reports.

Litchfield Park, Maricopa County, AZ (branch camp under Pima). This camp opened in February 1944. There were 564 Italian POWs working here in February and 748 German POWs working here in October 1944. Their work was agricultural.

Luke (Frank) Field, Maricopa County, AZ (branch camp under Florence), now Luke Air Force Base. The population was a portion of that listed under Florence since this was a branch camp of Florence.

Marana, Pima County, AZ (branch camp under Florence). The population was a portion of that listed under Florence since this was a branch camp of Florence.

Maricopa, Pinal County, AZ (branch camp under Florence). This camp opened in January 1946. The maximum population was 315 German POWs in January 1946.

McDowell Road, Phoenix, Maricopa County, AZ (branch camp under Florence). This camp opened in March 1944. The maximum population was 169 Italian POWs in April 1944.

Mesa, Maricopa County, AZ (branch camp under Pima). This camp was built in February 1944. The maximum population was 616 German POWs in November 1944. They worked in agriculture and military.

Mt. Graham, Graham County, AZ (branch camp under Florence). This camp opened in June 1945. The maximum population was 250 German POWs in September 1945. They worked in forestry.

Navajo Ordnance Depot, Bellemont, Coconino County, AZ (base camp) now called Camp Navajo. The camp opened in April 1945. The maximum population was 250 German POWs in May 1945, doing military work on the Indian reservation.

POW Camps by Location 59

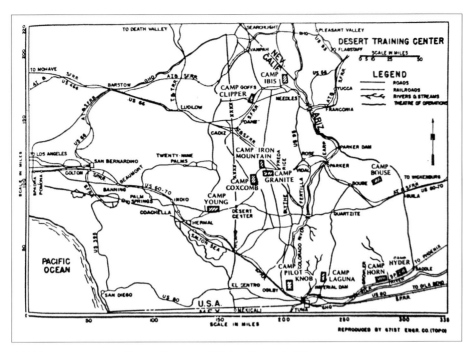

CAMA map, courtesy of Patton Museum, Chiriaco Summit, CA.

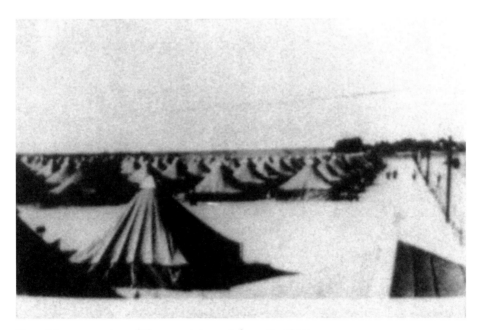

Camp Marana, courtesy of Florence, Arizona Information Center.

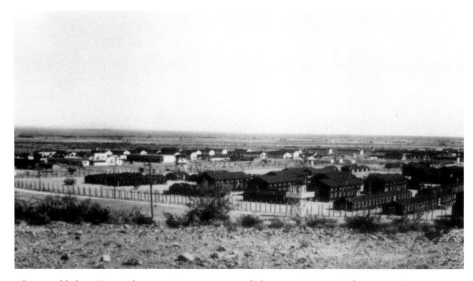

Above and below: Camp Florence views, courtesy of Florence, Arizona Information Center.

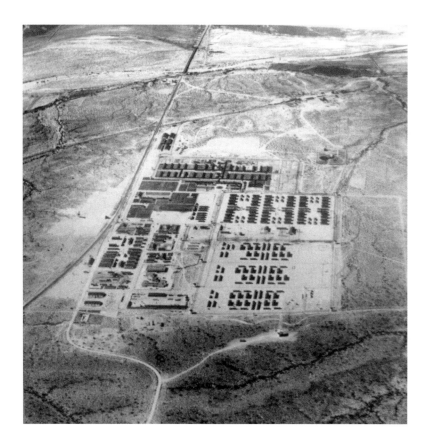

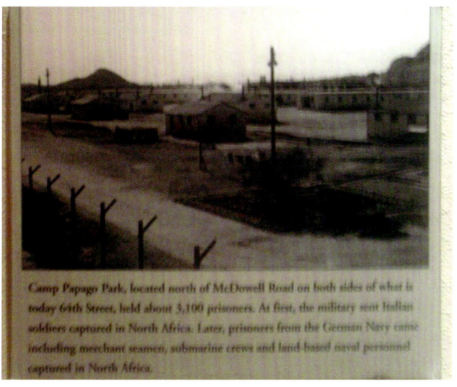

Camp Papago Park view and employee, photo by author from Arizona Historical Society Museum.

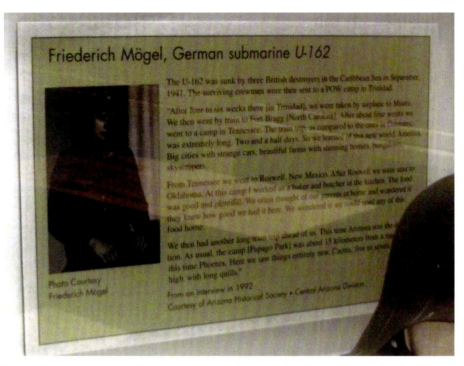

Former POW stories, photos by author from Arizona Historical Society Museum.

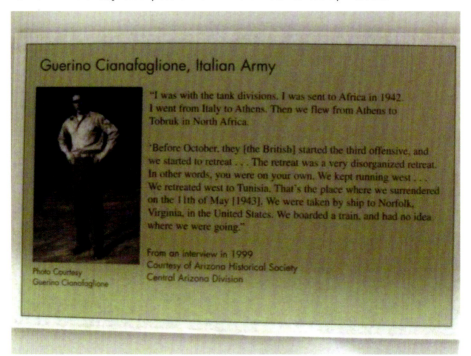

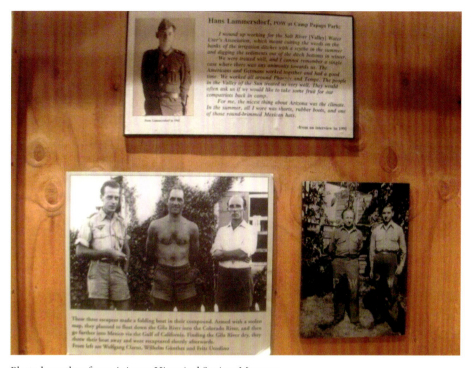

Photo by author from Arizona Historical Society Museum.

Papago Park POW Camp, Papago Park, Maricopa County, AZ (base camp). This camp opened in February 1944. The maximum population was 3,420 German POWs who worked in agriculture and military efforts. These men were primarily submarine crews. Here, a German POW was murdered by his former Nazi allies for revealing military secrets to Americans. Americans had promised to never place him in a camp with German submariners, but it happened, and he was killed within hours. The men who killed him, although they followed the same directives followed by all captured military, were sentenced to death and hanged at Fort Leavenworth after the end of the war. Not our proudest moment. This camp was also the location of the largest escape from an American POW camp. On 23 December 1944, twenty-five Germans tunneled out, heading for a river they expected to follow into Mexico. But, the river was dry. All had been re-captured in a few weeks.

Parker, La Paz County, AZ (branch camp under Pima). This camp opened in October 1944 as part of CAMA. The maximum population was 160 German POWs and six others (probably conscripts in the German army from countries they conquered during the war) in November 1944. They worked in agriculture.

Phoenix, Maricopa County, AZ (base camp, sometimes branch camp under Florence and under Haan, CA). It opened in June 1944. The maximum population was twenty-seven Italian POWs in June 1944. Their work was agricultural and military.

Pima Prisoner of War Camp, Papago Park, Maricopa County, AZ (base camp), bought by the City of Phoenix in 1959. This camp opened in January 1945. The maximum population was 109 German POWs in September 1945. Their work was military.

Queens Creek, Maricopa County, AZ (branch camp under Pima). This camp opened in November 1944. The maximum population was 396 German POWs in January 1945. They worked in agriculture.

Roll, Yuma County, AZ (branch camp under Pima, sometimes Florence). This camp opened in July 1944. The maximum population was 180 German POWs in August 1945, working in agriculture.

Safford, Graham County, AZ (branch camp under Florence). This camp opened in February 1944. The maximum Italian POWs were 225 in March 1944. The maximum German POW population was 1500 in August 1945. They worked in agriculture and military efforts.

Stanfield, Pinal County, AZ (branch camp under Florence). The population of this camp was included in the numbers for Florence since this was a branch camp of Florence.

Tolleson, Maricopa County, AZ (branch camp under Florence). This camp opened in February 1944. The maximum population was 234 Italian POWs in March 1944.

Yuma, Yuma County, AZ (branch camp under Pima, part of CAMA). This camp opened in March 1945 and housed a maximum of 348 Germans in June 1945. They worked in agriculture.

Yuma Test Station, Yuma, Yuma County, AZ. This camp opened in September 1945. It was populated by 640 Italian Service Unit members in September 1945.

In Nevada, there were Italian POWs at one location as follows:

Cal-Nev-Ari, Clark County, NV (part of CAMA). These men supplied support services for the US Army training at CAMA at an airfield used to bring men in and out of the CAMA training area.

POW Camps by Location

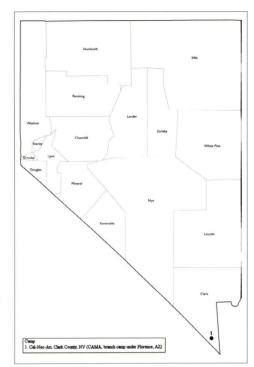

Right: Map of POW camp in Nevada, courtesy of John Saffell.

Below: Plaque at Cal-Nev-Ari, NV, photo by author

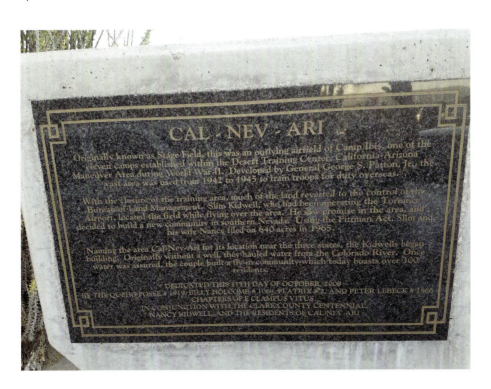

Death Index

A total of 901 Germans (includes three Russians, four Austrians, one Yugoslavian, one Czech and one Turk), 172 Italians, twenty-three Japanese (includes one Korean) out of 1,175 POWs who died while held in the US during WWI & WWII. The following twenty-five men died in Arizona and no men died in Nevada.

Carloni, Vasco, died at Roll, buried at Florence, AZ, transferred to Fort Bliss National Cemetery, TX

Cunto, Giuseppe, died and buried at Camp Florence, AZ, transferred to Fort Bliss National Cemetery, TX

Dorsch, Andreas, died and buried at Camp Florence, AZ, transferred to Fort Bliss National Cemetery, TX

Drechsler, Werner Max Herschel, died at Papago Park, buried at Florence, AZ, transferred to Fort Bliss National Cemetery, TX

Drewnick, Alois, died at Papago Park, buried at Camp Florence, AZ, transferred to Fort Bliss National Cemetery, TX

Frisan, Ruggero, died and buried at Camp Florence, AZ, transferred to Fort Bliss National Cemetery, TX

Kalbheim, Theodor, died at Navajo Ordnance Depot, buried at Florence, AZ, transferred to Fort Bliss National Cemetery, TX

Kleimann, Wilhelm, died at Papago Park, buried at Florence, AZ, transferred to Fort Bliss National Cemetery, TX

Koscheak, Max, died and buried at Camp Florence, AZ, transferred to Fort Bliss National Cemetery, TX

Lucchesi, Eligio, died and buried at Camp Florence, AZ, transferred to Fort Bliss National Cemetery, TX

Marino, Angelo, died and buried at Camp Florence, AZ, transferred to Fort Bliss National Cemetery, TX

Mele, Eugenio, died and buried at Camp Florence, AZ, transferred to Fort Bliss National Cemetery, TX

Peisker, Carl, died and buried at Camp Florence, AZ, transferred to Fort Bliss National Cemetery, TX

Russo, Salvatore, died at Imperial Dam, CA, buried at Camp Florence, AZ, tranferred to Fort Bliss National Cemetery, TX

Sambusiti, Alberto, died and buried at Camp Florence, AZ, transferred to Fort Bliss National Cemetery, TX

Sanna, Sevarino, died and buried at Camp Florence, AZ, transferred to Fort Bliss National Cemetery, TX

Scherlizki, Paul, died and buried at Camp Florence, AZ, transferred to Fort Bliss National Cemetery, TX

Schilhan, Karl, died at Navajo Ordnance Depot, buried at Florence, AZ, transferred to Fort Bliss National Cemetery, TX

Traunmueller, Rudolf, died in Maricopa County, buried at Camp Florence, AZ, transferred to Fort Bliss National Cemetery, TX

Uicich, Giovanni, died and buried at Camp Florence, AZ, transferred to Fort Bliss National Cemetery, TX

Vazzana, Domenico, died and buried at Camp Florence, AZ, transferred to Fort Bliss National Cemetery, TX

Vetter, Siegfried, died and buried at Camp Florence, AZ, transferred to Fort Bliss National Cemetery, TX

Vollmann, Ludwig, died at Papago Park, buried at Florence, AZ, Fort Bliss National Cemetery, TX

Wacker, Herman, died and buried at Camp Florence, AZ, transferred to Fort Bliss National Cemetery, TX

Zaccaria, Walter, died and buried at Camp Florence, AZ, transferred to Fort Bliss National Cemetery, TX

Burial Locations List

Place of Burial (in the United States): A total of ninety-one US Military and civilian cemeteries contained POW burials.

Arizona
Camp Florence, AZ (thirteen German and fifteen Italian WWII POW burials transferred to Fort Bliss, TX in June 1946)

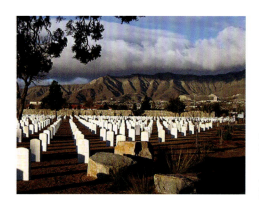

Left: www.cem.va.gov/CEM/cems/nchp/ftbliss.asp

Below: Funeral at Camp Monticello, AR, photo courtesy of Robert Todaro

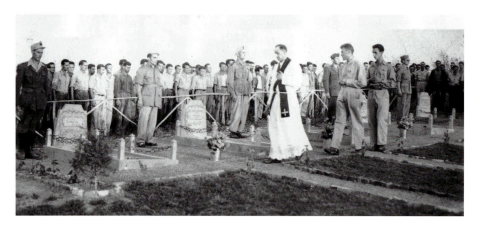

Appendix A

POW Labor

The following images are by the author from National Archives and Records Administration, College Park, MD, RG 389.

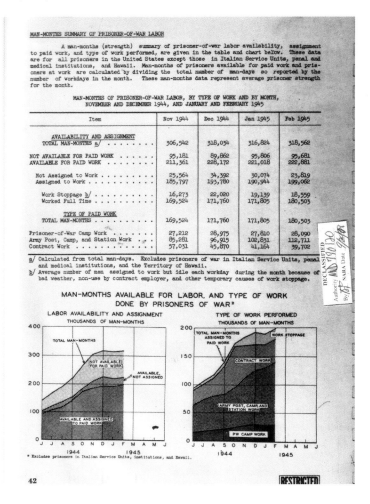

PRISONERS OF WAR WORK

CLOTHING AND EQUIPMENT

FORT MEADE, MD.

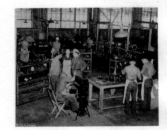

CAMP BLANDING, FLA.

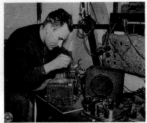

FORT McCLELLAN, ALA.

CAMP BRECKINRIDGE, KY.

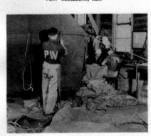

FORT OGELTHORPE, GA.

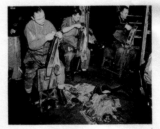

CAMP CARSON, COLO.

WD – ASF – PMGO

PRISONERS OF WAR WORK

POST ENGINEER WORK

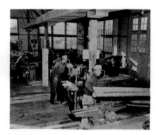

CAMP TRINIDAD, COLO.

CAMP SHELBY, MISS.

FORT LEONARD WOOD, MO.

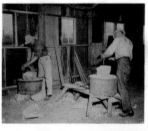

CAMP BRECKINRIDGE, KY.

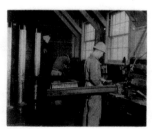

CAMP BRECKINRIDGE, KY.

CAMP WHEELER, GA.

WD – ASF – PMGO

PRISONERS OF WAR WORK

POST ENGINEER WORK

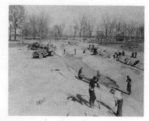
CAMP CLINTON, MISS.

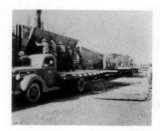
CAMP SUTTON, N. C.

EDGEWOOD ARSENAL, MD.

CAMP CARSON, COLO.

GALVESTON AAB, TEX.

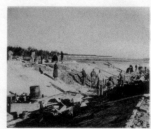
FORT LEONARD WOOD, MO.

WD – ASF – PMGO

PRISONERS OF WAR WORK

POST ENGINEER WORK

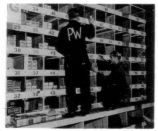
FORT BENJAMIN HARRISON, IND.

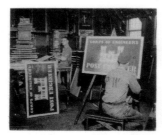
CAMP BRECKINRIDGE, KY.

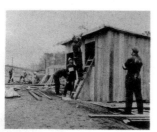
NORFOLK ARMY AIR BASE, VA.

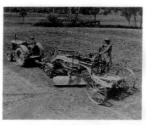
CAMP CLINTON, MISS.

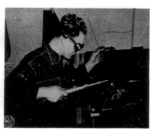
FORT DEVENS, MASS.

CAMP LEE, VA.

WD – ASF – PMGO

PRISONERS OF WAR WORK

MOTOR MAINTENANCE

FT. DIX, N. J.

FORT ROBINSON, NEB.

FORT KNOX, KY.

FORT DIX, N. J.

CAMP CAMPBELL, KY.

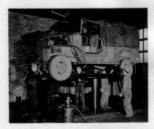
FT. BRAGG, N. C.

WD - ASF - PMGO

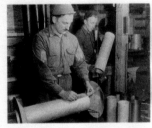

CAMP CLARK, MO.

FORT OGELTHORPE, GA.

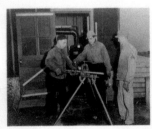

CAMP CLARK, MO.

FORT LEONARD WOOD, MO.

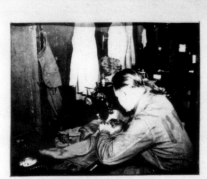
TAILOR, CLOTHING REPAIR SHOP

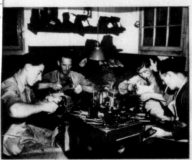
COBBLERS, SHOE REPAIR SHOP

MECHANIC, TYPEWRITER REPAIR SHOP

OCCUPATIONS AND SKILLS OF
PRISONERS OF WAR

Auto body repairmen
Auto painters
Auto mechanics
Artists
Bakers, bread and pastry
 Mixers
 Oven operators
 Moulders
 Dividers
Barbers
Blacksmiths
Bookkeepers
Boot and shoe repairmen
Boxmakers
Bricklayers
Brushmen
Bulldozer operators
Butchers
Cabinetmakers
Canvas workers
Carpenters
 Bench
 Car
 Concrete form
 House
 Rough
Car washers and greasers
Cement and concrete
 finishers
Ceramic workers
Checkers
Chemists
 Sewage disposal plant
Cleaners
 Engine
 Floor
 Machine
Clerks
 General office
 Statistical
 Stock
Clothing classifiers
Clothing repairmen
Coal handlers
Cobblers
Countermen
Concrete workers
Construction machinery
 operators
Construction laborers
Cooks
 EM mess
 Officers' mess
 PX restaurant
Coppersmiths
Cranemen
Craters
Dairymen
Dental lab. workers
Ditch diggers
Draftsmen
Dragline operators
Dyers
Electrical repairmen

Electricians
 Auto
 House
 Motor
 Radio
Engravers
Fan cleaners
Farm hands
Farm machinery operators
Firemen
 Boiler and furnace
 Fire department
Form builders
Flashlight repairmen
Freight handlers
Furnace cleaners
Furnace tenders
Furniture repairmen
Foundry workers
Garbage laborers
Garbage collectors
Gardners
Glaziers
Goldsmiths
Graders and packers
 Fruit and vegetable
Grass mowers
Grave diggers
Greenhouse workers
Grounds keepers
Harness makers
Harvest hands
 Cotton
 Fruit
 General
 Sugar beets
 Sugarcane
 Tobacco
 Vegetable
Hospital orderlies
Incinerator operators
Insect exterminators
Interpreters
Instrument repairmen
Irrigation workers
Janitors
Jewelers
Kitchen police
Laborer, general
Language teachers
Latrine orderlies
Laundry workers
 Checker
 Marker
 Presser
 Sorter
 Washer
Leather workers
Locksmiths
Lumberyard workers
Machinists
Masons
Meatcutters
Mechanics

OCCUPATIONS AND SKILLS OF
PRISONERS OF WAR (Continued)

Maintenance workers:
 Ditches
 Grounds
 Powerline right-of-way
 Railroad right-of-way
 Roads and streets
 Septic tanks
Model and pattern makers
Molders
Motor repairmen
 Electrical
 Gasoline and diesel
Nurserymen
Office-machine repairmen
Oilers
Orthopedic aids
Painters
 Construction
 Maintenance
 Vehicle
Paper balers
Photograph finishers
Photographers' assistants
Physicians
Piano tuners
Pinboys
Plasterers
Printers
Plumbers
Poultry dressers
Pulpwood cutters
Quarry workers
Radio repairmen
Ration breakdown workers
Repairmen
 Automobile
 Clothing
 Electrical
 Furniture
 Instrument
 Motor
 Office machine
 Radio
 Road equipment
 Shoe
 Tent
 Tire
 Typewriter
 Watch
Railroad maintenance workers
Refrigeration mechanics
Road equipment repairmen
Roofers
Salvage workers:
 Building materials
 Clothing and equipment
 Electrical equipment
 Motors
 Paper
Saw filers
Sawmill workers
Scrubmen
Servicemen, motor pool
Sheet metal workers

Sewage disposal plant operators
Shoe classifiers
Shoe repairmen
Sign painters
Silversmiths
Spray operators
 Mosquito control
 Tree spraying
Stablemen
Steam cleaners
 Vehicles
Steam fitters
Stonecutters
Stone masons
Storekeepers
Sweepers
Tailors
Teachers
Teamsters
Telephone linemen
Tent repairmen
Textile balers
Tile setters
Timekeepers
Tinsmiths
Tire changers
Tire repairmen
Tool checkers and sorters
Tool dressers and sharpeners
Track repairmen
Tree fallers
Tractor drivers
Truck drivers
Type setters
Typewriter repairmen
Typists
Upholsterers
 Furniture
 Vehicles
Veterinarians
Waiters
 EM mess
 Officers' club
 PX restaurant
Ward boys
 Station hospital
Warehousemen
 Post ordnance
 Post quartermaster
 Salvage shop
 Post exchange
 Private industry
Wash-rack man
Watch repairmen
Water plant operators
Weavers
 Basketry
Webbing repairmen
Welders
Woodsmen
Wood workers
X-ray lab. technicians
Yardmen

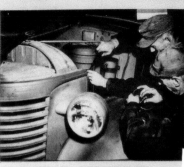

MECHANICS, VEHICLE REPAIR SHOP

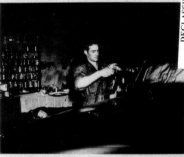

AUTO PAINTER, VEHICLE REPAIR SHOP

PLUMBERS, POST PLUMBING SHOP

COAT PRESSER, QM LAUNDRY

OVENMAN, POST BAKERY

YOU CAN USE PRISONERS OF WAR

You can use prisoners of war for nearly every kind of work. Experience has shown that they are well trained in many skills and are good workers if properly supervised. On the following pages are lists of some of the occupations and skills of prisoners now at work for the Army, and of the places they are being used on posts, camps and stations. New occupations and places of employment are being reported every day. The principal limit on the use of prisoners is the ingenuity of the Army personnel in their selection, training, and supervision.

Prisoners may be employed in those occupations which normally are necessary for the feeding, sheltering, and clothing of human beings as such, even though such work is performed for, or results in benefits to, members of the Military Establishment. The Geneva Convention prohibits only that employment which is solely of value in assisting the conduct of active belligerent operations. Prisoners are not used to handle explosives, weapons or any other lethal devices designed exclusively for combat, but relatively few operations at a post are of this character.

Most projects require no guard at all or only a roving guard who checks irregularly on several details. Many agencies report greater production from prisoners who work without continuous guards. Escapes are not a real hazard.

It is the policy of the War Department to use prisoners on all functions which can be satisfactorily performed by them at Army installations. Prisoner labor will displace troops on operating functions wherever possible. Read Prisoner of War Circular No. 24, War Dept., 1944, for complete statement of policy. <u>You</u> <u>can</u> <u>use</u> <u>prisoners</u> <u>of</u> <u>war</u>.

CABINET MAKER, CARPENTER SHOP

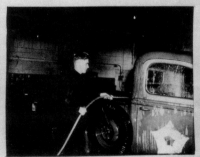
CAR WASHER, MOTOR POOL

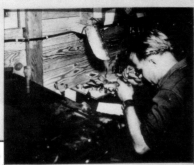
JEWELER, WATCH REPAIR SHOP

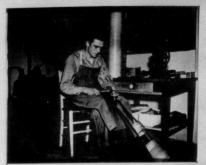
ADJUSTER, ORTHOPEDIC SHOP

WHERE PRISONERS OF WAR ARE BEING USED ON ARMY POSTS

Bakeries
Bowling alleys
Brush clearance projects
Building demolition projects
Building maintenance operations
Carpenter shops
Cemeteries
Chapels
Clothing and equipment shops
Coal yards
Combined maintenance shops
Dental laboratories
Ditch digging and maintenance projects
Electrical shops
Enlisted men's messes
Enlisted men's service clubs
Erosion control projects
Farms
Fire departments
Freight houses
Garbage disposal operations
Gardens
Greenhouses
Grounds
Harness shops
Heating plants
Hospitals
Ice plants
Incinerators
Laundries
Lumber reclamation projects
Lumber yards
Medical laboratories
Mosquito control projects
Motor pools
Packing and crating projects
Paint shops
Photographic laboratories
Officers' clubs and messes
Offices
Orthopedic shops
Plumbing shops
Post exchanges
Post theatres
Quarries
Railroad track maintenance projects
Reclamation shops
Recreational buildings and areas
Restaurants
Road construction and maintenance projects
Rock crushers
Salvage shops
Saw mills
Septic tank maintenance operations
Service stations
Sewage disposal plants
Sheet metal shops
Shoe repair shops
Stables
Surgical appliances shops
Tailor shops
Tent and canvas shops
Timber clearance projects
Tire shops
Typewriter repair shops
Vehicle repair shops
Warehouses
Watch repair shops
Water pumping stations
Wood lots
Wood piles
X-ray laboratories

Appendix B

Museums and Websites

Arizona Historical Society Museum, Papago Park, AZ - http://www.arizonahistoricalsociety.org/museums

Camp Atterbury – http://www.indianamilitary.org/CA%20POWs/SoThinkMenu/CAPOW-START.htm

Billion Graves – www.billiongraves.comCalifornia Military Museum – www.militarymuseum.org, also a brick and mortar location in Sacramento.

Camp Aliceville - www.encyclopediaofalabama.org/face/Article.isp?id-2322.

Camp Hearne Museum – http://camphearne.com/index.htm

Camp Opelika – http://www.eastalabama.org/Exhibits/Exhibits.htm

Camp Ruston – http://www.latech.edu/library/scma/index.php

Camp Van Dorn World War II Museum – www.vandorn.org

Cemetery Records Online - www.interment.net

Door County Maritime Museum, Sturgeon Bay, WI has display on WWII POWs in the area orchards

Drew County Museum, Monticello, AR has a display on WWII POWs at Camp Monticello.

Family Search - familysearch.org

Find a Grave - www.findagrave.comFort Douglas, Salt Lake City, UT – www.fortdouglas.org/about/virtual-tour, also cemetery

Fort George G. Meade Museum - http://www.ftmeade.army.mil/museum/Pages/Museum_POW.html

Fort Leonard Wood Museum - www.visitmo.com/museums-at-fort-leonard-wood.aspx

GenTracer – World War II - www.gentracer.org

History of Farragut State Park - http://parksandrecreation.idaho.gov/parks/farragut

Library of Congress - catalog.loc.govMarch Field Air Museum, Riverside, CA - www.marchfield.org

McFarland State Historic Park - https://azstateparks.com/mcfarland

Mississippi Armed Forces Museum, Camp Shelby, MS - www.armedforcesmuseum.us/Pages/Newsletter.pdf

Mississippi History Now – http://mshistory.k12.ms.us/index.php?id=233Under"

HYPERLINK "http://mshistory.k12.ms.us/index.php?id=233Under".k12.ms.us/index.php?id=233Under

Traces – www.traces.org

U.K. National Archives - www.nationalarchives.gov.uk

US Dept. of Veterans Affairs National Cemeteries - www.cem.va.gov/cem/cems/listcem.asp

US National Archives – www.archives.gov

U. S. National Park Service - www.nps.gov

Weber State University, Stewart Library, Special Collections Exhibits, "Prisoners of War in Ogden" - http://library.weber.edu/asc/POW/default.cfm

Bibliography

Adams, Meredith Lentz. "A Miscarriage of Justice?" interview by Jim Kelly. Sunflower Journeys Home 16101A. KTWU. 2003.

⎯⎯⎯. *Murder and Martial Justice: Spying and Retribution in World War II America*. Kent, Ohio: Kent State University Press, 2011.

⎯⎯⎯. "The Abortive Attempt to Exchange GI and German POWs". (Presentation, TRACES conference, 31 May 2003).

Alberts, Betty. Interview by author. 10 March 2012.

Amdt, Karl John Richard. "German P.O.W. Camp Papers." Microfilm. Washington, D.C.: Library of Congress Photoduplication Service, 1965. Library of Congress. http://lccn.loc.gov/83125121. Accessed 20 September 2012.

Angerilli, Adriano. Interview by author. 14 August 2009.

Arizona State Dept. of Health, Div. of Vital Statistics. Death Certificate #544 on 24 July 1944 at Camp Roll, Yuma County, Arizona. Vasco Carloni.

⎯⎯⎯. Death Certificate #574 on 8 February 1944 at Camp Florence, Pinal County, Arizona. Giuseppe Cunto.

⎯⎯⎯. Death Certificate #409 on 10 September 1945 at Camp Florence, Pinal County, Arizona. Andreas Dorsch.

⎯⎯⎯. Death Certificate #228 on 13 march 1944 at Papago Park, Maricopa County, Arizona. Werner Max Henry Drechsler.

⎯⎯⎯. Death Certificate #278 on 22 March 1945 at Papago Park, Maricopa County, Arizona. Alois Drewnick.

⎯⎯⎯. Death Certificate #514 on 8 May 1944 at Camp Florence, Pinal County, Arizona. Ruggero Frisan.

⎯⎯⎯. Death Certificate #68 on 14 December 1945 at Navajo Ordnance Depot, Coconino County, Arizona. Theodor Kalbheim.

⎯⎯⎯. Death Certificate #133 on 4 September 1945 at Papago Park, Maricopa County, Arizona. Wilhelm Kleimann.

⎯⎯⎯. Death Certificate #524 on 1 January 1946 at Camp Florence, Pinal County, Arizona. Max Koscheak.

_____. Death Certificate #498 on 1 April 1944 at Camp Florence, Pinal County, Arizona. Eligio Lucchesi.

_____. Death Certificate #540 on 17 March 1944 at Camp Florence, Pinal County, Arizona. Angelo Marino.

_____. Death Certificate #503 on 2 May 1944 at Camp Florence, Pinal County, Arizona. Eugenio Mele.

_____. Death Certificate #459 on 10 June 1945 at Camp Florence, Pinal County, Arizona. Carl Peisker.

_____. Death Certificate #457 on 1 September 1944 at Imperial Dam, Yuma County, Arizona. Salvatore Russo.

_____. Death Certificate #417 on 11 September 1944 at Camp Florence, Pinal County, Arizona. Alberto Sambusiti.

_____. Death Certificate #543 on 13 July 1943 at Camp Florence, Pinal County, Arizona. Servino Sanna.

_____. Death Certificate #529 on 3 February 1946 at Camp Florence, Pinal County, Arizona. Paul Scherlizki.

_____. Death Certificate #77 on 21 September 1945 at Navajo Ordnance Depot, Coconino County, Arizona. Karl Schilhan.

_____. Death Certificate #502 on 9 January 1945 in Maricopa County, Arizona. Rudolf Traunmueller.

_____. Death Certificate #551 on 27 March 1944 at Camp Florence, Pinal County, Arizona. Giovanni Uicich.

_____. Death Certificate #592 on 22 September 1943 at Camp Florence, Pinal County, Arizona. Domenico Vazzana.

_____. Death Certificate #511 on 30 May 1945 at Camp Florence, Pinal County, Arizona. Seigfried Vetter.

_____. Death Certificate #340 on 30 May 1944 at Papago Park, Maricopa County, Arizona. Ludwig Vollmann.

_____. Death Certificate #460 on 7 October 1945 at Camp Florence, Pinal County, Arizona. Hermann Wacker.

_____. Death Certificate #518 on 15 April 1944 at Camp Florence, Pinal County, Arizona. Walter Zaccaria.

Army Service Forces. Service Command Operating Personnel and Prisoners, 31 March 1945, NARA RG 389, Entry 261, Box 2563; National Archives at College Park, College Park, MD.

Boudreaux, Henry J, Capt., C.M.P. Report of Investigation of the deaths of Leonello Bini, Vito Clemente, Adolfo Nitri, Antonino Paleologo, 21 July 1943, NARA RG 389, Entry 461, Box 2562; National Archives at College Park, College Park, MD.

Bryan, B.M., Brigadeer General. Assistant Provost Marshal General, Letter to Army Services

Forces regarding transfer of POWs, 26 August 1944, NARA RG 389, Entry 457, Box 1419; National Archives at College Park, College Park, MD.

Bulkat, Ernst. Interview by author. 11 March 2007.

Busco, Ralph A. "Italian Prisoners of War and Italian Service Unit Camp Newsletters," 1965. Special collections, Merrill-Cazier Library, Utah State University, Logan, Utah.

Bykofsky, Joseph and Harold Larson. *United States Army in World War II: The Technical Services: The Transportation Corps: Operations Overseas.* Center of Military History, United States Army, Washington, D.C., 2003.

Carlson, Lewis. "POW Experience: Myth and Reality". (Presentation, TRACES conference, 6 October 2002).

Conn, Stetson and Byron Fairchild. *The United States Army in World War II, The Western Hemisphere, The Framework of Hemisphere Defense.* Washington, D.C., Office of the Chief of Military History, Department of the Army, 1960.

Conn, Stetson and Rose C Engelman and Byron Fairchild, *The United States Army in World War II, The Western Hemisphere, Guarding the United States and its Outposts.* Washington, D.C., Office of the Chief of Military History, Department of the Army, 1964.

Cosentini, George and Norman Gruenzner. *United States Numbered Military Post Offices Assignments and Locations 1941-1994.* The Military Postal History Society, 1994.

Cowley, Betty. *Stalag Wisconsin: Inside WWII Prisoner-of-war Camps.* Oregon, WI: Badger Books, 2002.

Cunningham, Raymond Kelly. *Prisoners at Fort Douglas: War Prison Barracks Three and the alien enemies, 1917-1920.* Salt Lake City, Utah: Fort Douglas Military Museum, 1983.

Daugherty, Joseph B., Col. Assistant, Office of the Quartermaster General, Letter to Provost Marshal General regarding repatriation of ISU units, dated 9 October 1945, NARA RG 389, Entry 261, Box 2563.

_____. Letter to Provost Marshal General regarding repatriation of ISU units, dated 28 August 1945, NARA RG 389, Entry 261, Box 2563.

"Department of Veterans Affairs National Cemeteries," United States Department of Veterans Affairs, last modified 13 July 2012. http://www.cem.va.gov/cem/cems/listcem.asp.

Ducharme, Joseph O.C., Lt. Col. Director, Enemy PW Information Bureau, Camp Holabird, MD, to Provost Marshal General, regarding cemetery locations, dated 16 February 1953, NARA RG 389, Entry 261, Box 2562.

_____. Regarding cemetery locations, dated 16 February 1953, NARA RG 389, Entry 467, Box 1513.

Dvorak, Petula. "Fort Hunt's Quiet Men Break Silence on WWII". *Washington Post.* 6 October 2007.

Edwards, Earl L., Lt. Col. Asst. Dir., Prisoner of War Division, Letter to Army Services Forces, regarding prisoner segregation, dated 3 March 1944, NARA RG 389, Entry 261, Box 2563.

BIBLIOGRAPHY

_____. Letter Regarding Prisoner Transfer, dated 16 October 1943, NARA RG 389, Entry 261, Box 2563.

_____. Letter Regarding Prisoner Transfer, dated 7 January 1943, NARA RG 389, Entry 261, Box 2563.

Enemy Prisoner of War Information Bureau. World War II Enemy Prisoners of War Deceased in Theaters of Operations, Fort Holabird, MD, 2 July 1952, NARA RG 389, Entry 466, Box 1.

Erichsen, Heino R. *The Reluctant Warrior: Former German POW Finds Peace in Texas. Austin, TX*: Eakin Press, 2001.

_____. Interview by author. 7 October 2002.

Fairchild, Byron and Jonathan Grossman. *United States Army in World War II: The War Department: The Army and Industrial Manpower*. Center of Military History, Department of the Army, Washington, D.C., 2002.

Farrand, Stephen M. Major, Prisoner of War Operations Division, Letter to Special War Problems Division regarding the death of Karl Schaeffer, dated 28 May 1945, NARA RG 389, Entry 261, Box 2562.

_____. Letter to Special War Problems Division regarding the death of Alfred Malinowski, dated 20 February 1945, NARA RG 389, Entry 261, Box 2562.

"Find a Grave," Find a Grave. http://www.findagrave.com/.

Fischer, H. P., Office of the Commanding General, Ninth Service Command, Fort Douglas, UT, Letter to Army Service Forces regarding new base camps, dated 31 March 1945. NARA RG 389, Entry 457, Box 1419.

Ford, George. "German Guard Held in Medical Ward After Shooting 28 Germans: Probe Opened by Army into Salina Affair". *The Deseret News*, 9 July 1945.

Gansberg, Judith M., Stalag: *USA: The Remarkable Story of German POWs in America*. New York, NY: Thomas Y. Crowell Company, 1977.

Giordana, Beth. Interview by author. August 2001.

Griffith, L. E. Lt. Col., Prisoner of War Operations Division, Letter to Mrs. Ada Errera regarding transfer of body to Italy, dated 30 April 1946, NARA RG 389, Entry 261, Box 2562.

Barbara Schmitter Heisler, "Returning to America: German Prisoners of War and the American Experience," *German Studies Review*, Vol. 31, No. 3 (Oct., 2008), pp. 537-556; Published by: The Johns Hopkins University Press on behalf of the German Studies Association.

Heitmann, John A. "Enemies are Human." (Presentation, Dayton Christian-Jewish Dialogue, 10 May 1998).

Iannantuoni, Mario. Interview by author. 10 February 2012.

Jones, L.B.C. Lt. Col. Deputy Director, Internal Security Division, Regarding Security, dated 14 October 1943, NARA RG 389, Entry 261, Box 2563.

Keefer, Louis E., *Italian Prisoners of War in America, 1942-1946: Captives or Allies?*, New York, NY: Praeger, 1992.

Kirkpatrick, Kathy. "Italian POWs in Utah." (Presentation, TRACES conference, 7 October 2002)

_____ (Presentation, TRACES conference 31 May 2003).

Knappe, Siegfried & Ted Brusaw. *Soldat: Reflections of a German Soldier 1936-1949*. New York, NY: Orion Books, 1992.

Krammer, Arnold. "American Treatment of German Generals" *The Journal of Military History* 54, No. 1 (January 1990): 27-46.

_____. "German Prisoners of War in the United States" *Military Affairs* 40, No. 2 (April 1976): 68-73.

_____. *Nazi Prisoners of War in America*. Lanham, MD: Scarborough House, 1996.

Leighton, Richard M., and Robert W. Coakley. *The United States Army in World War II, The War Department, Global Logistics and Strategy 1940-1943*, Washington, D.C., Office of the Chief of Military History, Department of the Army, 1955.

Lewis, George G, and John Mewha. *History of Prisoner of War Utilization by the United States Army, 1776-1945*. US Department of the Army, Pamphlet 20-213, Washington, D.C.: Government Printing Office, 1955.

Lucioli, Ezio. Interview by author. 14 August 2009.

Luick-Thrams, Michael. "The Fritz Ritz: German POWs in the American Heartland" (Presentation, TRACES conference, 31 May 2003).

Margotilli, Giuseppe. Interview by author. 14 August 2009.

Martin, Charles E., Col., Director of Personnel, Memorandum to Armed Service Forces, regarding release of ISU, dated 3 October 1945, NARA RG 389, Entry 261, Box 2563.

_____. Memorandum to Armed Service Forces, regarding release of ISU, dated 23 August 1945, NARA RG 389, Entry 261, Box 2563.

_____. Memorandum to Armed Service Forces, regarding release of ISU, dated 20 August 1945, NARA RG 389, Entry 261, Box 2563.

Moore, John Hammond. "Italian POWs in America: War is Not Always Hell." *Prologue* (Fall 1976): 141-151.

_____. *Wacko War: Strange Tales from America 1941-1945*. Raleigh, NC: Pentland Press, 2001.

Nagler, Joerg A. "Enemy Aliens and Internment in World War I: Alvo von Alvensleben in Fort Douglas, Utah, a Case Study." *Utah Historical Quarterly* 58 (Fall 1990): 388-406.

Nash, Gerald D. *The American West Transformed: The Impact of the Second World War*. Bloomington, IN: Indiana University Press, 1985.

National Archive Record Group 389.

News of the Week, Utah ASF Depot, Ogden, Utah, 3 September 1943.

Noble, Antonette Chambers. "Utah's Defense Industries and Workers in World War II." *Utah Historical Quarterly* 59 (Fall 1991): 365-380.

_____. "Utah's Rosies: Women in the Utah War Industries During World War II." *Utah Historical Quarterly* 59 (Spring 1991): 123-146.

Orsini, August. Interview by author. 7 October 2011.

Palermo, Raffaele. "ISU Personnel Records." Al Ministero della Difesa, Roma, Italy.

Parri, Dino. *Il Giuramento; Generale a El Alamein, prigioniero in America (1942-1945)*. Milano: Mursia, 2009.

"Per il Soldato Francesco Erriquez la guerra è finita!," *Un Mondo di Italiani*, last accessed September 26 2012. http://www.unmonditaliani.com/per-il-soldato-francesco-erriquez-la-guerra-e-finita.htm.

Pisani, Pat and Maria. Interview by author. 12 June 2009.

Powell, Allan Kent. *Utah Remembers World War II*. Logan, UT: Utah State University Press, 1991.

_____. *Splinters of a Nation; German Prisoners of War in Utah*. Salt Lake City, UT: University of Utah Press, 1989.

_____. "Our Cradles Were in Germany: Utah's German American Community and World War I." *Utah Historical Quarterly* 58 (Fall 1990): 371-388.

Prisoners in Paradise, DVD, directed by Camilla Calamandrei. 2001.

"Prisoners of War in Ogden: 1943-1946," Weber State University Stewart Library, last modified 23 December 2008. http://library.weber.edu/asc/POW/default.cfm.

Pulia, Peter A., Sr. Interview by author. 1 May 2002.

Reiss, Matthias. "Bronzed Bodies behind Barbed Wire: Masculinity and the Treatment of German Prisoners of War in the United States during World War II." *The Journal of Military History* 69, No. 2 (April 2005): 475-504.

Richards, Su. Interview by author. 23 May 2009.

Rogers, John R. Interview by author. 3 September 2007.

Salgado, Rebecca C. "Rebuilding the Network: Interpretation of World War II Prisoner-of-War Camps in the United States." (Master's Thesis, Columbia University, May 2012).

Scott, Ralph. "Violations of International Law in the Treatment of German POWs Following the Cessation of Hostilities." (Presentation, TRACES conference, 1 June 2003).

Smith, Clarence McKittrick. *United States Army in World War II: The Technical Services: The Medical Department: Hospitalization and Evacuation, Zone of Interior*. Center of Military History, United States Army, Washington, D.C., 2003.

Spidle, Jake W. Jr. "Axis Prisoners of War in the United States, 1942-1946: A Bibliographical Essay." *Military Affairs* 39, No. 2 (April 1975): 61-66.

"State Department-Related Sites: Hotels and Resorts," German American Internee Coalition, last accessed 20 September 2012. http://www.gaic.info/ShowPage.php?section=Internment_Camps.

Thomas, Jennie M. *History of the Prisoner of War Camp Utah ASF Depot*, Ogden, Utah, 1 February 1945.

Thompson, Antonio S., *Men in German Uniform: POWs in America during World War II*. Knoxville, TN: University of Tennessee Press, 2010.

Tissing, Robert Warren Jr. "Utilization of Prisoners of War in the United States During World War II: Texas, A Case Study." (Master's Thesis, Baylor University, 1973).

Todaro, Robert J. Interview by author. 12 June 2006.

Togni, Fernando. Interview by author. 14 August 2009.

Tollefson, A. M., Col., Director, Prisoner of War Operations, Letter to Special Projects Division regarding the death of Giovanni Cincotta, dated 10 January 1946, NARA RG 389, Entry 462, Box 2562.

_____. Letter to Special Projects Division regarding the death of Giovanni E. Bondini, dated 8 June 1945, NARA RG 389, Entry 261, Box 2562.

_____. Letter to Special Projects Division regarding Salina shooting, dated 28 August 1945, NARA RG 389, Entry 261, Box 2562.

Trezzani, Claudio. Letter from Monticello PW Camp, AR, dated 26 January 1944. Stato Maggiore Esercito, #2256A, Roma.

Ulio, J. A., Major General, the Adjutant General's office, letter to The Commanding Generals, dated 9 April 1943. NARA RG 389, Entry 261, Box 2563.

University of Utah. *Historic Fort Douglas at the University of Utah, a Brief History & Walking Tour.* Salt Lake City, UT: University of Utah, 2000.

Urwiller, Clifford S., Col. Prisoner of War Operations Division, Memorandum for Camp Operations Branch regarding surplus ISU units, dated 18 October 1945, NARA RG 389, Entry 261, Box 2563.

_____. Memorandum for Camp Operations Branch regarding surplus ISU units, dated 14 September 1945, NARA RG 389, Entry 261, Box 2563.

US House. Report of Committee on Military Affairs. 78th Congress., 2nd sess., H. Res. 30.

US House. Report of Committee on Military Affairs. 79th Congress., 1st sess., H. Res. 20.

War Department, to Commanding Generals, Regarding movement orders, dated 14 November 1945, NARA RG 389, Entry 261, Box 2563.

_____. Regarding movement orders, dated 1 November 1945, NARA RG 389, Entry 261, Box 2563.

_____. Regarding movement orders, dated 23 October 1945, NARA RG 389, Entry 261, Box 2563.

_____. Regarding movement orders, dated 18 September 1945, NARA RG 389, Entry 261, Box 2563.

Wardlow, Chester. *United States Army in World War II: The Technical Services: The Transportation Corps: Movements, Training, and Supply.* Center of Military History, United States Army, Washington, D.C., 2003.

Weyand, A. M., Col. Commanding, Prisoner of War Camp, Ogden, UT, Letter regarding prisoner segregation, dated 21 January 1944, NARA RG 389, Entry 261, Box 2563.

Wilcox, Walter W. "The Wartime Use of Manpower on Farms." *Journal of Farm Economics* 28, No. 3 (Aug. 1946): 723-741.

Winter, Richard. "Hot Springs, NC. A World War I Internment Camp." *North Carolina Postal Historian* 27, no. 1 (2008)

"WWI German Prisoners of War in Utah," GenTracer, last accessed 26 September 2012. http://www.gentracer.org/WWIGermanPrisonersofWarinUtah.html.

"WWI Internment Camp in Hot Springs, NC: The German Village," Welcome to Madison County, North Carolina, accessed Sept 1, 2012. http://www.visitmadisoncounty.com/who-we-are/town-of-hot-springs/the-german-village-wwi-internment-camp/.

Acknowledgments

Christine Saffell (researcher and travel companion)
Karrie and Jenefer Jackson (data entry)
Kate and John Saffell (website, data entry, photos)
Alessandro de Gaetano (producer, screenwriter of Red Gold)
Barbara Harvey (Mother, support, great memory for events in her lifetime, AZ)
Dave Kendziura (historian, Hill AFB, Clearfield, UT)Davis
Gina McNeeley (photographic expert, NARA researcher)
Karen Jensen and Pam Frisbie (my sisters who share the lure of the stories behind the headstones)
Kenneth D. Schlessinger (NARA II, College Park, MD)
Kent Powell (Utah Historical Society, Salt Lake City, UT)
Col. Maurizio Parri (grandson of General Dino Parri, an Italian POW at Camp Monticello, AR)
Michael Luick-Thrams (TRACES founder, IA)
Michael Pomeroy (authority on Camp Monticello, AR)
Rhonda Jackson and Lucia Rogers (researchers, AZ)
Sarah Langsdon (Special Collections, Weber State University, Ogden, UT)
Stefano Palermo (son of Raffaele Palermo, an Italian POW in California and Arizona)
Su Richards (historian, Ft. Douglas Museum, Salt Lake City, UT)

Index

AAF 25
Africa 8, 14, 36, 44
Alaska 25
Albanians 18
Algeria 14
Algiers 14
Aliceville 80
Aliens 5, 8, 11, 12, 18, 86
Angerilli 52, 82
AR 18, 80, 88, 90
Arizona 55, 66, 68, 80, 82, 90
Armstrong 17
ASF 4, 13, 18, 20, 22, 25, 27, 33, 35, 42, 45, 50, 86
Atterbury 4, 31, 45, 50
Australia 14, 54
Austrians 46, 66
AZ 48, 80, 90

Badoglio 43
Beale 20
Blanding 20
Bliss 66
Bosnia 18
Bouse 55
British 8, 14, 18
Buckeye 56
Bulkat 51, 84
Bushnell 18, 27
CA 12, 15, 48, 80
Calamandrei 53, 87
California 56, 90
California-Arizona Maneuver Area (CAMA) 56
CAMA 56
Campbell 20
Canada 14
Casa Grande 56

CCC 18, 42
Center 56
Chattanooga 9
Clark 56
Clearfield 90
Clinton 23
Como 16
Continental 56
Cortaro 56
Cotton Center 56
Croatia 18
Crossville 23
Czech 18, 46, 66

D'Onofrio 24
Dateland 56
Davis 57
Davis-Monthan Army Air Base 57
Dermott 23
Deseret 85
Devens 9, 20
DOJ 18
Douglas 4, 8, 10, 18, 46, 80, 84, 88, 90
Dow 58
Duncan 57

Eager 43
Egypt 14
Eilert 46
Eleven Mile Corner 57
Eloy 57
England 54
Erichsen 52, 85
Erriquez 46, 87
Ethiopians 18

Facchini 46
Farragut 80
Fascist 23, 42
Florence 48, 56, 64, 66, 82
Fort Douglas 4, 8, 10, 18, 46, 84, 88
France 8, 16, 48
Franco 23
French 8, 14

G-2 15, 20, 23
GA 8
Geneva 18, 20, 25, 27, 29, 36, 44, 46, 48
Genoa 49
German 5, 8, 14, 18, 20, 23, 25, 27, 43, 45, 48, 50, 55, 66, 82, 85, 89
Gibraltar 14
Giordana 49, 53, 85
Grant 9, 49
Great Britain 14, 48
Greece 16, 54

Haan 64
Hawaii 25, 54
Hearne 80
Henry 82
Hereford 4, 17, 20, 29, 36, 52
HI 17
Hill Field 18
Honolulu 17
Horn 57
Hospital 18, 25, 26, 55
Hot Springs 9, 15, 89
Hungarian 18
Hunt 14, 18, 46, 84

Iannantuoni 52, 85
ID 4, 16
Idaho 55
Imperial Dam 58
India 14, 29
Indiana 50, 86
INS 9, 18
ISU 17, 20, 23, 33, 35, 41, 48, 57, 64, 84, 86
Italian 5, 14, 16, 20, 22, 25, 27, 29, 35, 41, 48, 64, , 66, 84, 86, 90
Italy 5, 16, 22, 34, 36, 43, 49, 85, 87

Jackson 9, 90

Japan 6, 12, 14, 18, 25, 46, 48, 51, 66
Kenya 14
Korean 46, 66
KY 50

LA 17, 48
Lawton 17
Leavenworth 8
Libya 14
Lipscomb 6
Litchfield Park 58
Logan 84, 87
Long Island 14
Longo 4, 50
Lordsburg 36
Los Angeles 56
Louisville 50
Luciolli 52
Luke 58
Luke (Frank) Field 58

MA 9, 49
Marana 58
March 8, 43, 82
Margotilli 52, 86
Maricopa 56, 58, 63
McDowell 58
McDowell Road 58
McPherson 8
Meade 80
Mesa 58
Middle East 14
MO 20
Mongol 18
Monmouth 36
Monticello 18, 20, 23, 43, 53, 80, 88, 90
MS 16, 80
Mt. Graham 58
Mussolini 17, 42

Naples 49
NARA 53, 55, 83, 88, 90
Nashville 6
National Archives 6, 25, 53, 81, 83
Navajo Ordnance Depot 58
Nazi 20, 23, 46, 86
Nevada 1, 64

Index

New Caledonia 55
New York 14, 27, 85
New York City 14
NJ 36
NM 36
North Africa 8, 14, 44
Nova Scotia 49
NPS 14
NY 18, 27, 48, 85

Ogden 4, 18, 22, 24, 31, 34, 36, 44, 49, 81, 86, 90
Oglethorpe 8
ONI 15
Opelika 80
Orem 51
Orsini 52, 87

Papago Park 63
Parker 63
Parri 52, 87, 90
Philippines 55
Phoenix 58, 64
Pigeon Forge 15
Pima 56, 63
Pisani 49, 87
PMGO 9, 15, 18, 36, 43
Pulia 54, 87

Queens Creek 64

Ravarino 4, 54
Red Cross 27, 30, 36
Reunion 4, 50, 52
Riverside 56
Roll 64
Rome 6, 42, 53
Russians 46, 66
Ruston 17, 80

Safford 64
Saggese 49
Salina 85, 88
Salt Lake City 8, 44, 53, 80, 84, 87, 90
San Bernardino 56
San Francisco 12
SC 9, 48
Seattle 17
Selmi 34

Service Command 6, 11, 12, 18, 43, 83, 85
Sevier 9
Sherman 9
Slavs 18
Slovenia 18
South Africa 14
Spain 23
Stanfield 64
Storm 54
Sturgeon Bay 80
Swiss 18, 30

Tennessee 6, 88
Thomas 20, 54, 85, 87
Todaro 20, 54, 88
Togni 52, 88
Tolleson 64
Trezzani 23, 42, 88
Tunisia 16, 54
Turk 46, 66
Turrini 4, 16, 54
TX 4, 17, 29, 36, 52, 85

Umbarger 4, 36, 41
USSR 48
UT 4, 8, 10, 12, 18, 20, 27, 36, 45, 51, 53, 80, 85, 87, 90
Utah 4, 13, 18, 20, 25, 27, 34, 43, 45, 50, 53, 84, 86
Utah ASF 4, 13, 18, 20, 25, 27, 35, 43, 45, 50, 86

VA 14, 18, 48
Van Dorn 80
Vatican 6
Vecchio 4, 22
Vermont 25

WA 49
Wadsworth 9, 43
war brides 49
Weingarten 20
Wood 20, 80
WWI 8, 11, 18, 66, 89

YMCA 30, 36
Yugoslavian 46, 66
Yuma 56, 64

Also by Kathy Kirkpatrick

American Prisoner of War Camps in Idaho and Utah
978-1-63499-041-7
$22.99